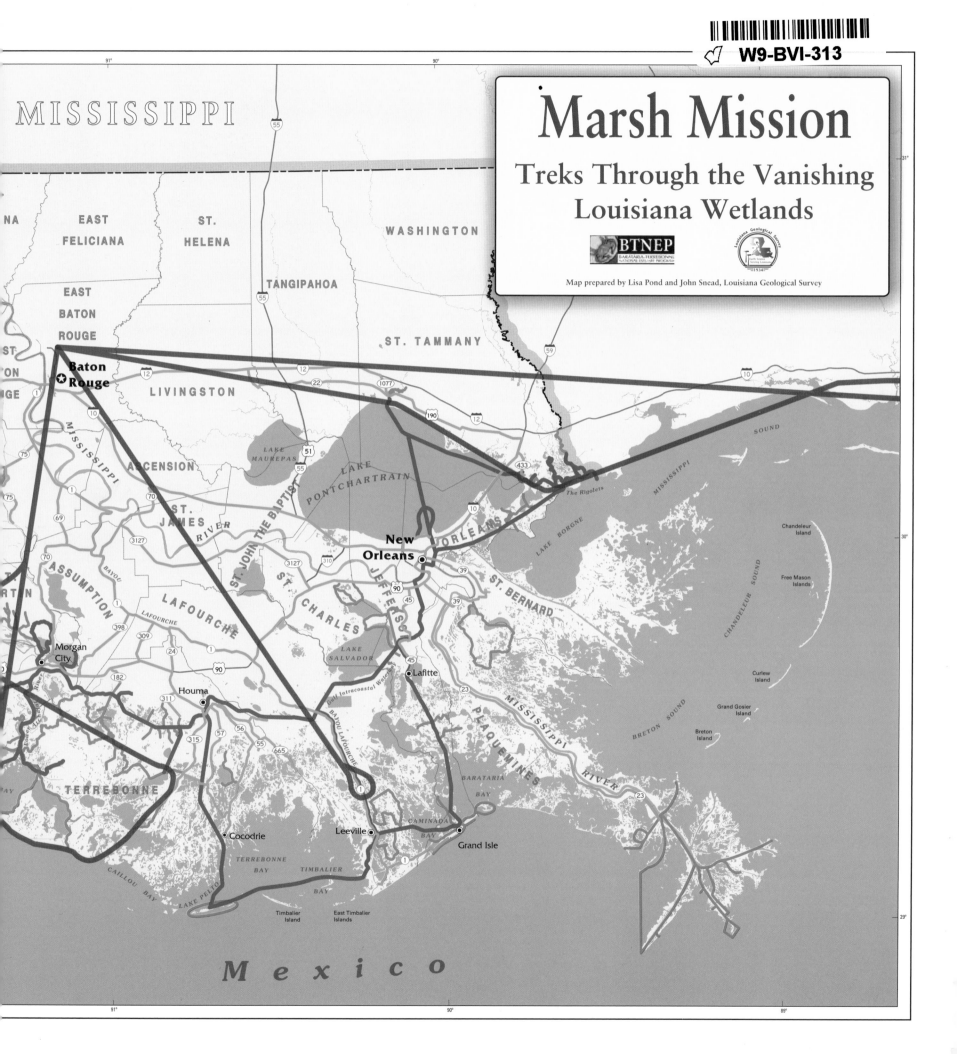

Marsh Mission

Treks Through the Vanishing Louisiana Wetlands

BTNEP
BARATARIA-TERREBONNE
NATIONAL ESTUARY PROGRAM

Louisiana Geological Survey

Map prepared by Lisa Pond and John Snead, Louisiana Geological Survey

Marsh Mission

CC Lockwood

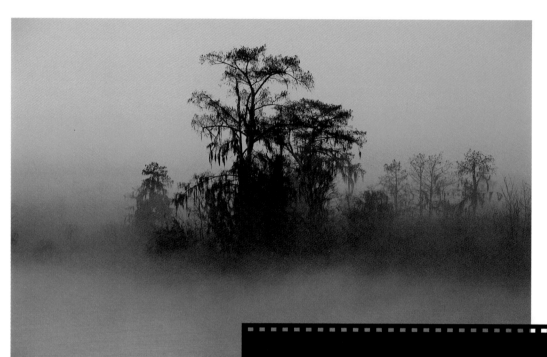
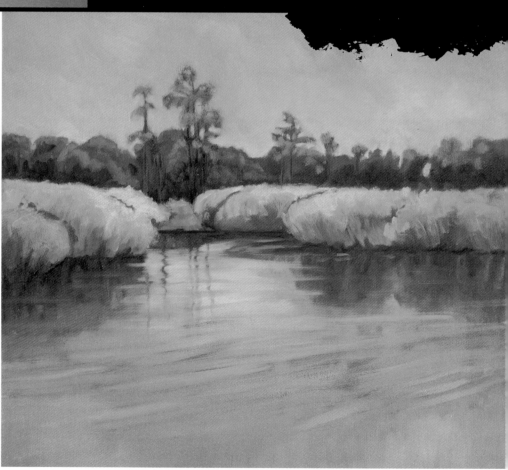

Marsh Mission

C.C. LOCKWOOD

RHEA GARY

Capturing the Vanishing Wetlands

LOUISIANA STATE UNIVERSITY PRESS

BATON ROUGE

Copyright © 2005 by C. C. Lockwood and Rhea Gary
All rights reserved
Manufactured in China
First printing

Designer: Laura Roubique Gleason
Typeface: Whitman
Printer and binder: Everbest Printing Co. through Four Colour Imports,
 Ltd., Louisville, Kentucky

Library of Congress Cataloging-in-Publication Data

Lockwood, C. C., 1949–
 Marsh mission : capturing the vanishing wetlands / C. C. Lockwood,
Rhea Gary.
 p. cm.
 ISBN 0-8071-3096-6 (cloth : alk. paper)
 1. Nature photography—Louisiana. 2. Wetlands—Louisiana—Pictorial
works. 3. Lockwood, C. C., 1949– I. Gary, Rhea. II. Title.
TR721.L63 2005
779'.3'09763—dc22

 2004025932

The paper in this book meets the guidelines for permanence and durability
of the Committee on Production Guidelines for Book Longevity of the
Council on Library Resources. ∞

OTHER BOOKS BY C. C. LOCKWOOD

Atchafalaya: America's Largest River Basin Swamp

The Gulf Coast: Where Land Meets Sea

Discovering Louisiana

The Yucatán Peninsula

C. C. Lockwood's Louisiana Nature Guide

Beneath the Rim: A Photographic Journey Through the Grand Canyon

Around the Bend: A Mississippi River Adventure

Still Waters: Images, 1971–1999

The Alligator Book

To Frank, my dad, without whose guidance in my younger life this book would never have been possible.

—CCL

With great love and respect, I dedicate this book of wetland images to my husband Leon, whose love and trust have sustained me on this journey.

—RG

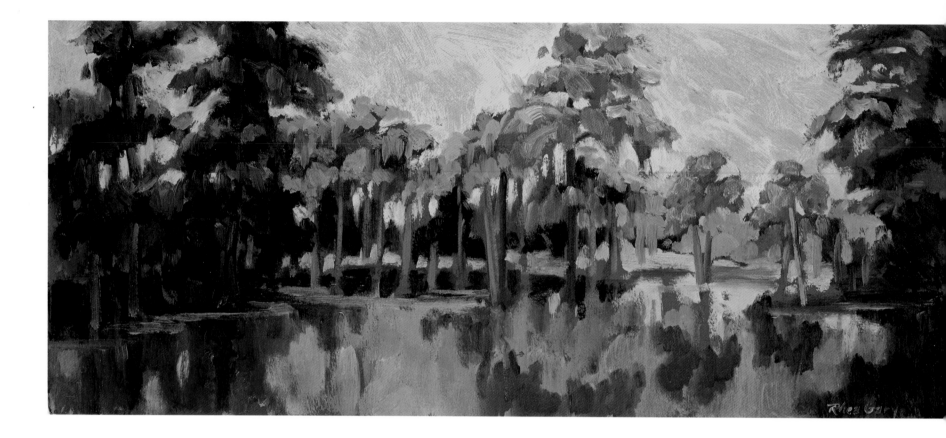

We cannot solve problems by using the same kind of thinking we used when we created them.

—Albert Einstein

Contents

Acknowledgments xi

Houseboat Journey through the Wetlands
 Photographs and an essay by C. C. Lockwood 1

Marsh Mission
 Paintings and an essay by Rhea Gary 15

Plates 27

Epilogue
 Photographs and text by C. C. Lockwood 87

List of Plates 101

Acknowledgments

Marsh Mission would not have been possible without the help of hundreds of good citizens and many organizations. De Laine Emmert is responsible for getting us together. Ron Becker and Elizabeth Coleman of the Louisiana Sea Grant College Program helped us with advice and a program development grant. Laura Lindsay of the LSU Art Museum and Chuck Wilson of LSU's Department of Oceanography and Coastal Science provided a key ingredient of the project, the houseboat. Rhea's brother-in-law Don Gary charted our Marsh Mission journey (as shown on the fine endsheet map by Lisa Pond and John Snead) and edited almost everything on the project's Web site.

Other major sponsors without whom this book would not have been possible are Bollinger Shipyards, Louisiana State University, the Louisiana Department of Natural Resources and its Atchafalaya Basin Program, Nikon USA, the Barataria-Terrebonne National Estuary Program, Jamestowner Houseboats, 2theadvocate.com, Gulf Coast Wireless, Redstick Internet Services, and JP Morgan Chase.

Additional sponsors were XFORCE, the Renaissance Group, Taylortec, iopn Design Group, Denbury Resources, A to Z Marine, the Louisiana Association of Waterways Operators and Shipyards, Canal Barge Company, Digital Pro, New Orleans Map Company, Bombardier Recreational Products, and Patagonia. We are also grateful for information provided by the Louisiana Department of Wildlife and Fisheries, the U.S. Geological Survey, the U.S. Department of the Interior, the National Park Service, local tourism bureaus, and the Louisiana Office of Tourism.

Lack of space prevents us from listing the hundreds of individuals who helped us in the wetlands and in our research. But we have listed them on our Web site at

http://www.marshmission.com/thankyou.cfm. We apologize if we inadvertently left anyone out, but no one who's helped us has been forgotten in our hearts and minds.

C.C. would particularly like to thank his project manager Megan Pearson Bertrand and the rest of his staff: Mary Wall, Meaghan Landry, Jamie Johnson, and Lindsey Bofinger, all of whom helped us keep everything in order while we lived on the houseboat for most of a year. C.C. also thanks Bruce Hammett, who was very helpful in securing funding, and Ray Cheramie, Ed Watson, Jimbo Roland, Bart Brumfield, and many other friends and family members who chipped in along the way. Thanks also to Natalie Smith for her illustration of the effects of marsh erosion. Many marinas helped us by donating dock space while C.C. and his wife, Sue, went home to develop film and do research. The Houma Municipal Marina, which served as our central location as we crisscrossed the state, deserves special thanks. Others we thank are Marina Del Ray, Pirates Cove Marina, Franklin City Dock, the McIlhenny Company, Doyle Berry, the Paul J. Rainey Sanctuary, and the Bowtie Marina. The Lockwoods' dog, Annie the Marsh Mutt, was a trooper dressing up for all her Web photos. And most of all C.C. thanks his wife, Sue, who is perhaps the only wife in the world who would follow her husband's dream of living on a houseboat for a year, braving weather, waves, and those ever-present pesky mosquitoes, and contribute to the mission with her writing for the Coastal Correspondent for kids.

Rhea would like to thank her family and friends for all of their support and prayers, which have sustained her throughout this project. Her staff, Kerri Pepper, Sarah Stevens, and Andrew Julian, provided wonderful support. Thanks also to David Humphreys and Wes Kroninger for their excellent photography of Rhea's artwork. Special thanks go to De Laine Emmert, who helped make Rhea's dream of doing this book a reality. Rhea is grateful to Elizabeth Coleman, who encouraged her to begin the book and helped with the writing. Brother-in-law Don Gary not only edited her journals but kept her laughing with his e-mails. He offered praise and criticism in equal doses, both warmly appreciated. Rhea's sister Dede Lush was a companion in the marsh. They often praised their late father, George Dyson Jones, for teaching them self-reliant boatmanship. Their sister Jackie Tandy was ever supportive. Rhea also thanks her son, David Gary, who first took her into the wetlands in his boat many years ago. While he fished and Rhea painted, they shared a deep love of nature. Rhea's daughter Emily Gary Branum has been a constant encouragement. When things were hectic, she always said, "Mom, you can do it." Rhea's daughter Cherie Gary provided public relations advice and even wrote last-minute press statements. Throughout the project Rhea's husband, Leon, was a constant support. He often drove the boat, carried painting supplies, corrected Rhea's writing, cooked while Rhea painted, and trusted her on extended stays in the swamps. Through it all, he prayed each day that God would give her fresh inspiration to interpret His creation.

Finally, both artists would like to thank LSU Press, its director, MaryKatherine Callaway, designer Laura Gleason, project manager John Easterly, and editor George Roupe.

Marsh Mission

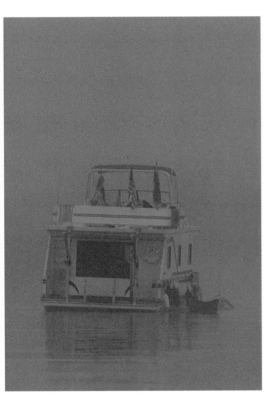

Houseboat Journey through the Wetlands

C. C. LOCKWOOD

AUGUST 27, 2004: *Gentle waves lap against the hull of the* Wetland Wanderer *as our flags flap carelessly in the yellow-orange glow of sunrise. It's cool, real comfy compared to the humid ninety-three-degree sauna we will have in a few hours. The weatherman says the heat index will be 106. Like the wind-chill factor the TV meteorologist pawns off on us in the winter, this figure doesn't matter to critters out here. They live with the weather day in and day out or migrate out of here if it gets too hot or cold for them. Sue and I have had to adapt with them since we launched this voyage ten months ago, spending most of our time at the mercy of the elements. Like a turtle, we have a shell, our houseboat, the* Wetland Wanderer, *to keep the rain off our backs, yet we are here day in and day out just like the wildlife so we can see, hear, feel, and smell the pulse of the wetlands. That's exactly why we chose this method to bring public awareness to the critical land-loss problem here in Louisiana that affects the entire United States.*

The sun I am looking at is poking its fiery head above a stand of bald cypress trees, drab in their summer-worn green dress. One mile beyond them is Lafitte, Louisiana, and in front is the Gulf Intracoastal Waterway, the Bayou Segnette Waterway, Bayou Villeras, and the eastern edge of Lake Salvador. Laughing gulls circle lazily overhead. They were named that because some ornithologist thought their call sounded like a laugh, but to me it sounds more like a scolding cry. The deep drone of a tug's massive diesel engine reverberates from down the Intracoastal Waterway, while the higher-pitched staccato of a crabber's lugger rattles closer by. He is pulling up his traps near our anchorage. Before dawn a bass boat whizzed by en route to bass or redfish nearby.

To the north-northeast about fifteen miles is Davis Pond, a $110 million freshwater diver-

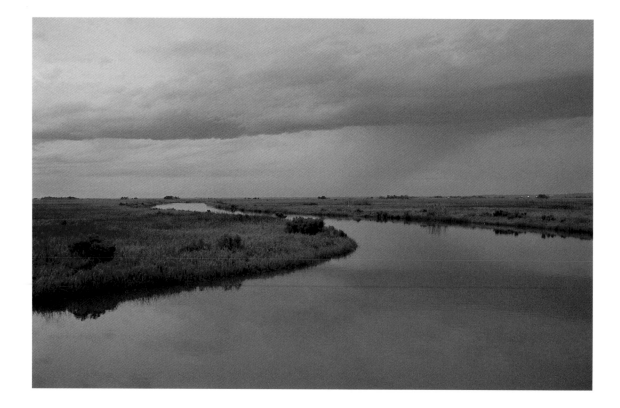

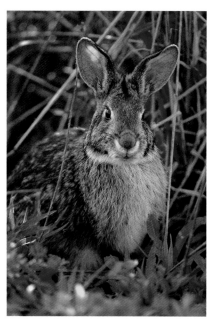

sion project, one of many needed coastal restoration solutions. A little closer, between Lake Salvador and Lake Cataouatche, a dragline builds up an eroding finger of oak- and shell-covered shoreline. It's a National Park Service project to beef up a coastline losing sixty-five feet per year in some places. Within sight on the southwestern edge of the lake is a sign just like thousands of others I have seen on this adventure, saying, WARNING: DO NOT ANCHOR OR DREDGE. NATURAL GAS PIPELINE.

At Lake Salvador, we see and hear it all, just as we did each day at every stop along the 2,700 miles we voyaged by houseboat, the 3,200 miles we floated by bateau, and the many more miles we traveled by airplane, helicopter, and truck. No matter how far out we go into the marsh, we hear, see, and feel the active presence of man, and no matter how close we get to a community, lock, shipyard, or tug pushing a six-pack of barges, we see and hear wildlife. What I have learned most this year is that we are all tangled up in a maze of pipelines, industry, and marine commerce that interacts with community, culture, recreation, and tourism. All the while, this hodgepodge of human activities depends upon the natural elements, the minerals, flora, and fauna that make up this bountiful coast. The difficulty of putting all those ingredients in a pot and cooking up a gumbo that will make everyone happy continues to be one of the most complex problems facing Louisiana. Yet we share these riches with the rest of America, and we need all Americans' help to save these valuable resources.

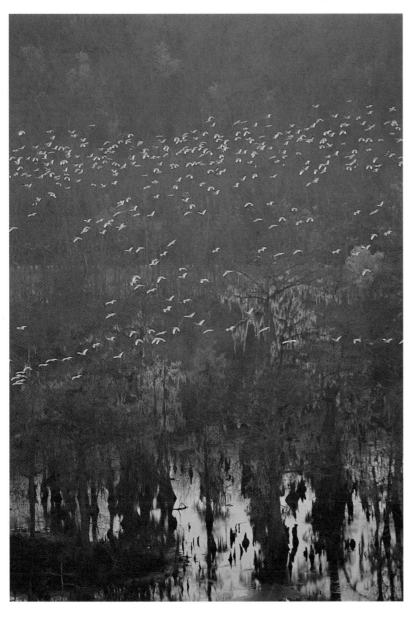

AUGUST 28, 2004: *The low rumble of a freight train carrying a hundred or so National Guard vehicles drowned out the ovation of the clapper rail, a secretive bird that walks among the stems of marsh grasses, often heard but rarely seen. Our boat was anchored in the deep waters of Unknown Pass just south of Lake St. Catherine where the railroad bridge blocks navigation for big boats. Yet there was room enough beneath the bridge for four boatloads of fishermen to cast for small croakers, a tasty fish. In the opposite direction great egrets stretched their wings to fly away from a small oak tree roost where they spent the night. I had photographed them in the full moonlight the night before. The stately white birds looked like Christmas ornaments in the silver glow of the moonlight. An even-topped field of smooth cordgrass stretched out flatly to the horizon, and the pungent salty smell of brackish marsh was in the air.*

AUGUST 29, 2004: *Twenty miles farther the next day we were in sight of Mississippi on the West Pearl River, our easternmost goal. The marsh was a patchy mixture of plant species with some shrub-sized trees such as wax myrtle and Chinese tallow giving it an almost woodsy look, yet one step in and the feel of the ground would tell you: walk gingerly and think like a web-footed duck or you'll sink. Water hyacinth drifted down the river filling the air with a watermelon-like scent I have smelled so often in the Atchafalaya Basin. The flocking blackbirds in the hog cane and balls of undulating swallows in the sky were signs of fall. Fishermen in skiffs and old runabouts tended their hooks and nets. Small tugs passed close during the night on their way out to the Rigolets.*

What we saw in those three late-August days reflects much of the variety of the wetlands experience, but what we saw in a year reminded me once again that south Louisiana—twenty coastal parishes with more than 13,000 square miles of mostly wetlands—is truly a paradise, one to be seen through all the seasons, from dawn to dusk and throughout the night. Our goal was to see it from the Atchafalaya Basin in the north to the Gulf of Mexico in the south, from Mississippi in the east to Texas in the west—a goal we achieved.

JUNE 30, 2004: *Last Island. The stern is facing the Gulf of Mexico. Brisk southeastern winds cool the* Wetland Wanderer *and blow the mosquitoes across Lake Pelto and into the marshes. The terns scream as twilight fades and the brown pelicans flap by to their rookery on Raccoon Island. I see a black skimmer skim by, its lower beak slicing the calm water of this canal like a hot knife in butter. Snap! A minnow. I look down into the muddy waters and see hundreds of schooling cocahoe minnows at the stern. I turn on the fishing lights and estimate over a thousand. Catfish are gulping them in splashy charges to the surface. Later I see a raccoon on the bank as the tide falls. In my spotlight, he stares at me while continuing to feel for food in the shallow water. He looks skinny soaking wet.*

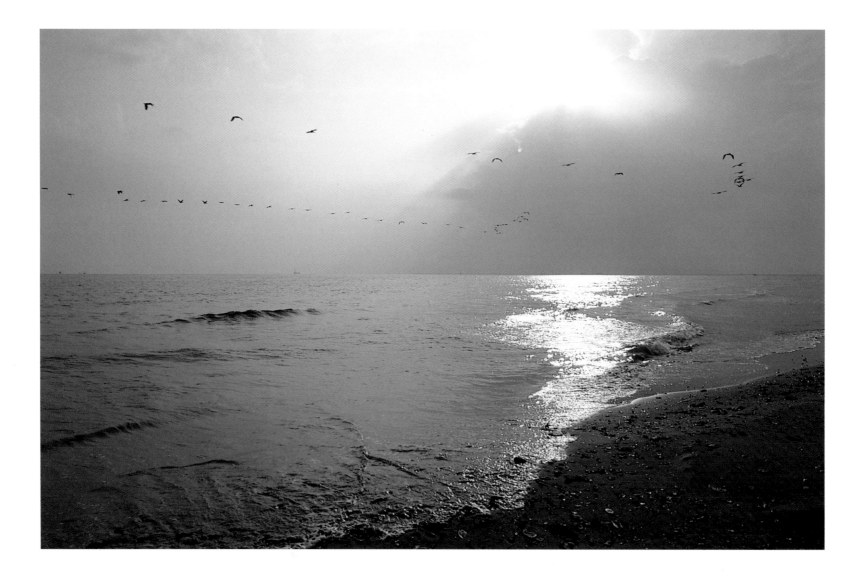

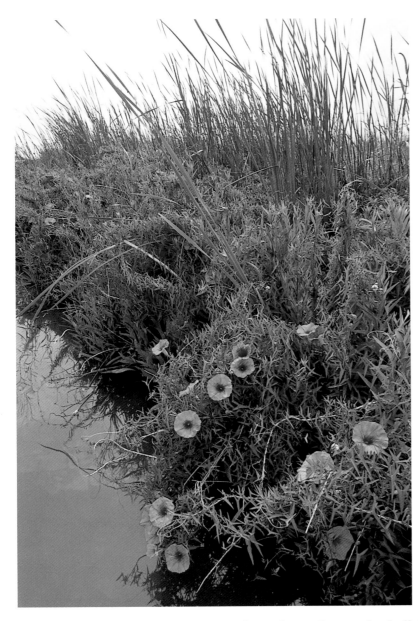

Last Island, also know as Isles Dernieres, is now actually four islands: East, Trinity, Whiskey, and Raccoon. The day after I saw the pelicans en route to Raccoon Island, I took the dinghy to the east end of Trinity Island, and the dunes there were magnificent: sugary white sand stacked eight to ten feet and covered in a lush green Mohawk of bitter panicum and a few other species of marsh grasses. Between them marsh pink bloomed with morning glories. This end of the island was refurbished by a Coastal Wetlands Planning, Protection, and Restoration Act (CWPPRA) project completed in 1999. A grand-looking success to me. Sue did not get to see it; she had taken the week off for some minor surgery. So a few weeks later I brought her back. The barrier islands are our first line of defense, speed bumps in the Gulf that protect the bays, marshes, wildlife, and people from storm surges and the incessant southeast breezes of summer that bring an endless line of waves. The repetitive sound is wonderful, but the relentless banging on the coast adds to the erosion.

Sue needed to see this, for the beauty and the wildlife and as an example of coastal restoration to share with the kids following her educational journaling on the Marsh Mission Web site. But when I came back with Sue, Mr. Sun shined hard and hot, and the wind had fallen to a dead calm. Great for the ride out, for it was smooth sailing, but it was so hot we could have baked a chicken inside the houseboat. Our turtle shell does have an air conditioner, but it takes fuel, and we only had enough to run it a few hours a night. To make the run out and stay for a week, we always had to save enough gas to get back and keep a reserve for emergencies. Not only did we have the heat to deal with, but without the wind, the mosquitoes came back, too, and the gnats. I just had to fix the beauty of the island in my mind to drown out the sounds of a miserable wife. In her defense, I was miserable too.

But the misery of hot summer days is nothing compared to Mother Nature's wrath in the form of hurricanes, especially the one of 1856, which knocked down every structure on this island and killed 140 people. At that time the island was thirty-eight miles long with a couple of small hotels and a community. It was a substantial barrier that took the brunt of this storm on the chin. Now Shea Penland, a barrier island expert doing research out of the University of New Orleans, tells me that the four major islets that remain (East

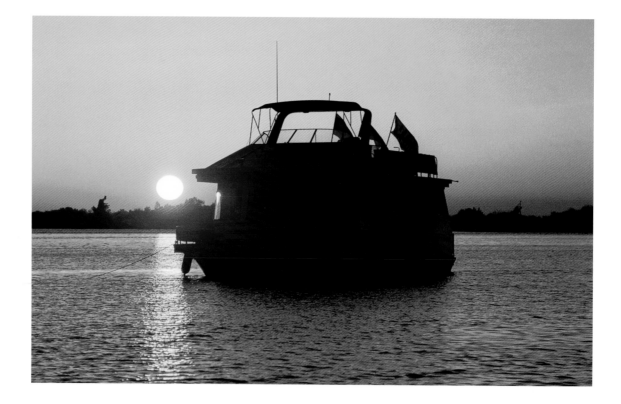

Island, Trinity, Whiskey, and Raccoon) of this once-solid land mass would have been gone by 2014 if not for the CWPPRA project. Shea says currently Trinity Island still loses thirty to forty feet per year to normal erosion, much more when there are hurricanes. In 1992 Hurricane Andrew caused 160 feet of erosion here. In 2002 Hurricanes Isidore and Lili claimed 293 feet. I watched hunks of wire grass encased in clay spall off the beachfront of Trinity Island. In September 2004 Hurricane Ivan scared the pants off New Orleans residents as 1,200,000 people evacuated southeast Louisiana, but Ivan changed his course and the city was spared. Without the protection of substantial barrier islands, it will be a huge disaster when the big one does hit the Big Easy.

DECEMBER 31, 2003: *Grand Isle. Hot here in the summer, but when you're catching speckled trout with your buddies, sometimes you don't notice. Sue and I were cold but well bundled as we took the dinghy out into Barataria Pass. The eddies, tides, current, and wildly changing depths here must have something to do with the richness seen at this time in winter. First we noticed the dolphins who were putting on a show splashing, tail-slapping, and leaping out of the water in pairs. We weren't sure if they were playing, fighting, or courting, but it was nonstop. Above were the birds, hundreds of brown pelicans, black skimmers in flocks of five hundred, cormorants rafted together in scores, and countless laughing gulls following the fishing boats. Truly a wildlife*

photographer's paradise. Stopping on the beach at Grand Terre to set my tripod up for sunset, I got a gorgeous winter golden glow below a wedge of clouds with all the aspects of the coast again: birds, mammals, sports fishermen, commercial boats, and the industry on Grand Isle in the background.

FEBRUARY 1, 2004: *Leeville marsh. At the foot of the oyster grass were oysters exposed at low tide, but that's all we could see as the fog rolled in as thick as oyster stew. Catching great ghostly images for my Nikon and rat redfish for Sue was about all we could do locked into this anchorage. What we couldn't see was disappearing anyway, for the Leeville marsh is sinking fast. About two miles away is the Leeville Bridge, a high-rise structure over Bayou Lafourche; anyone who has been over it ten to twenty years ago and crosses it again today will be amazed by the difference they see, the marsh gone.*

FEBRUARY 19, 2004: *Terrebonne Parish. We are anchored in an old oil location canal about eight hundred yards from the Intracoastal Waterway. We can hear the big tugs pushing barges or about any other structure that will float. At dawn a low-lying fog covers the waterway as I venture out in the dinghy and pass a fisherman checking his trotlines that stretch along the banks attached to sapling tree poles. He slaps a fifteen-inch blue catfish into his boat as I pass. I'm looking for the ultimate sunrise location, and I find it: an old barge with thirty-foot-tall oil tanks on it. I climb on to get my angle. Mission accomplished, I motor down Hanson Canal and into Mandalay National Wildlife Refuge. The swamp red maples are gorgeous in the backlit foggy morning. Spring will start popping up any day now. I shoot till I burn the batteries up. Ibis are feeding everywhere. It's beautiful here—green shoots bursting out of the willows, cypress, and red maples. Sue and I linger.*

Eight days later, spring had arrived. I saw four alligators on an airboat tour of the refuge with wildlife manager Paul Yakupzack. For the next few days we doubled our alligator sightings each day until we got tired of keeping track.

APRIL 5, 2004: *Atchafalaya Bay. Spring is still here. I am so glad, for it's my favorite season, and my favorite sign of spring in the wetlands is the giant blue iris bloom. In selected areas, it covers the delta fresh marsh, and it also blooms along the bayous and on the newly accreted land.*

Here is one of the few places on the coast with a net gain of land. As the major distributary of the Mississippi, the Atchafalaya River brings sediment to the shallow waters of Atchafalaya Bay and builds new land. Eric Dement, caretaker at the state wildlife management area here,

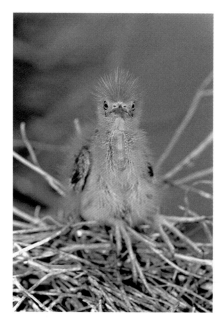

took me to a new island in the bay. This one was augmented by dredge materials in one of the many projects to enhance land growth. Walking across the newly formed island, we found deer and raccoon tracks; not a sprig of grass and it is already being checked out by the local wildlife. By summer's end it will be covered in grass and young willow trees.

Eric was a trapper and fisherman by trade until he took this job; he spent thirteen years after he got out of high school trapping alligators, lining catfish, netting crawfish, and catching lubber grasshopper. Every season this productive wetland provided a bounty of fur and fish to feed his family. Now his job as caretaker provides health insurance for him and his family and a guarantee that he can provide for them in the future.

MAY 26, 2004: *Calcasieu Lake. The prize of spring is animal babies, and we got to see some in one of many rookeries across coastal Louisiana. Sammie Faulk, fishing guide, ecotourism expert, and jack-of-all-trades, loaned me his blind at a wading-bird colony. The island's being predator free allows birds of ten species to nest in luscious green smooth cordgrass. It was covered with birdlife. Some laughing gulls were courting, while others were sitting on their nests in pairs. Cute couples. At sunset the egrets stood out like neon in Las Vegas as the golden rays of fading sunlight outlined their fluffed breeding plumage. All the while, massive tankers traveled up and down the Calcasieu Ship Channel carrying goods to and from Lake Charles, and sportsmen tossed their hooks baited with shrimp and cocahoe minnows for the big trout this lake holds.*

MAY 31, 2004: *White Lake. To the north, rice country and tugs pushing barges, and the most pristine fresh marsh in the state to the south. Managed to a tee for years by Amoco as a duck hunting club and since donated to the state, this marsh along with the Paul J. Rainey Sanctuary owned by the National Audubon Society were the best-looking marshes we came across. "Man-*

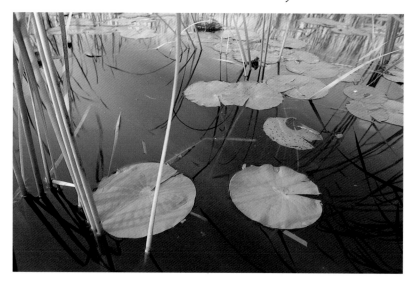

aged" is the word here. With a levee and pumps and limited access, these properties look good. It takes money and hard work to keep up a place like this, but even with management, these marshes, too, will vanish if we allow Louisiana's coastline to subside with no replenishment.

Many of the reporters who visited us wanted to see the destruction, the sinking marsh. I'd tell them, if you didn't see the marsh ten years ago from this spot, I can't show you what's gone because it's gone. I recently flew over Terrebonne Parish trying to match up some of the shots I took in the late seventies for a before-and-after comparison. But I

soon realized that so much of the land was gone I couldn't find any points of reference to line up the shots.

Even scientists had trouble convincing politicians and business leaders the land was disappearing until they got high-speed computers and satellite imagery to show the loss in black and white. I shared a podium at a banquet with Tulane environmental law professor Oliver Houck around that time. Scientists were just coming up with figures that we were losing twenty to fifty square miles of land per year along the coast. As Ollie put it, "If Texas annexed fifty square miles of Louisiana's coast, we would go to war! Yet the political community doesn't even notice as it sinks away."

Yet there are places where you can see it. If you fly over the Intracoastal Waterway in Calcasieu Parish, you can see it in an obvious plume of silty water flowing off the south bank, in contrast with the clearer water of the center and the north side, where rocks have been placed by a CWPPRA project to protect the marsh on that side. You can see it in the

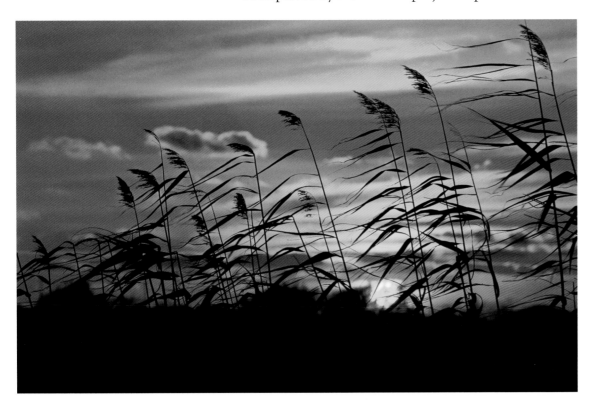

exposed roots of the marsh grass along the banks of the duck pond at Paul J. Rainey Sanctuary. Refuge manager Tim Vincent told me that pond was nothing more than a pothole a few years ago, before Isidore and Lili hit. Now it's two hundred yards wide and a mile long, and each time the winds change, more wire grass sloughs off. When I stood in the surf watching the waves tear off chunks the same way at Trinity Island, I could almost feel it.

One reason the destruction is hard to see is that, even though we have lost so much land (1,900 square miles sunk and eroded away in the last century), many species of wildlife thrive in great numbers in the great expanses of marsh that are still there. What gives?

I have seen more brown pelicans, great egrets, bald eagles, raccoons, white-tail deer, and alligators this past year than I did in the seventies, and I have gotten closer to them. Confused at first, I tried to understand why, if our wetlands are vanishing, so many species of wildlife seem more plentiful than ever. The fact is that our management and protection

of many of these species has paid off and they have increased in number, even though their habitat has declined. At the same time, more people than ever before are going into the marsh for both recreation and industry. We seem to see more birds and animals because they are getting used to us, and we are squeezing them into a smaller space.

I was still confused about how more wildlife could be surviving on less habitat until I saw an illustration in *WaterMarks,* a magazine funded through the CWPPRA. In three panels it showed a healthy marsh, an eroding marsh in the early stage, and an eroding marsh almost gone. Fish, shrimp, crabs, and other aquatics need room near the water's edges to hide and breed. As you can see in the illustration, the early stage of marsh erosion (center panel) leads to more fish habitat. That's where we are now, the boom before the bust for wildlife.

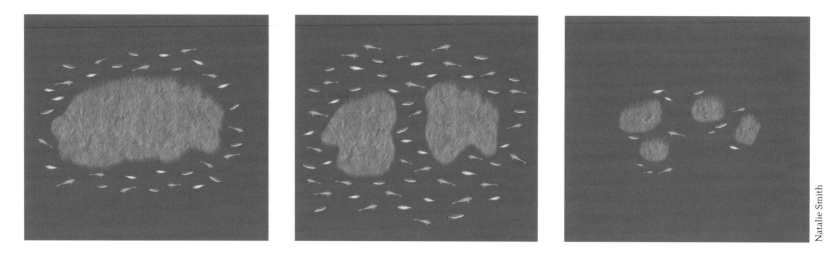

Natalie Smith

I've seen evidence of this everywhere we've been along the coast in the muddy, fish-rich mass of water encroaching on the land—a melting pot of liquid from so many places, a blend of clear, silty, and vegetated and black, green, blue, and brown that comes with the current from rivers, bayous, streams, and lakes to the north and moves in with the tide from the south. The richness of the land itself comes from this circulation of water, which for thousands of years has deposited sediment, minerals, and life from the ocean and across the continent in these wetlands.

But this wonderful gift of land is sinking, compacting, and being pulled toward the center of the earth by the natural force of gravity. Until recently, the sinking soil was constantly built back up with new deposits. Now, however, the dams and levees we've built to protect our homes have upset the delicate balance, and not enough of the precious soil from the heartland is reaching its natural destination in America's wetlands. Instead, coastal Louisiana is sinking at a rate of eleven millimeters (almost half an inch) per year.

Cruising across Timbalier Bay and Terrebonne Bay recently in the houseboat, we

passed through waters six to eleven feet deep. Local residents have told me their grand-fathers drove cattle across these bays to Timbalier Island. It seemed hard to believe: if this happened, say, a hundred years ago, we would have sunk about four feet since then. It seems to me that cows would have a hard time walking ten to twenty miles in two to seven feet of water.

Coastal Geologist Shea Penland straightened me out on this by showing me the fingers of land at the outfalls of delta distributaries on an old map of Louisiana. This is where the cows walked, speculated Shea. Similar ridges a little higher, some flanked by hurricane levees, are where many of our Cajun neighbors live, play their music, send their kids to school, and make their living. Their land is sinking too and one day will be under water, just like the now sunken ridges where they once drove their cattle across Timbalier Bay.

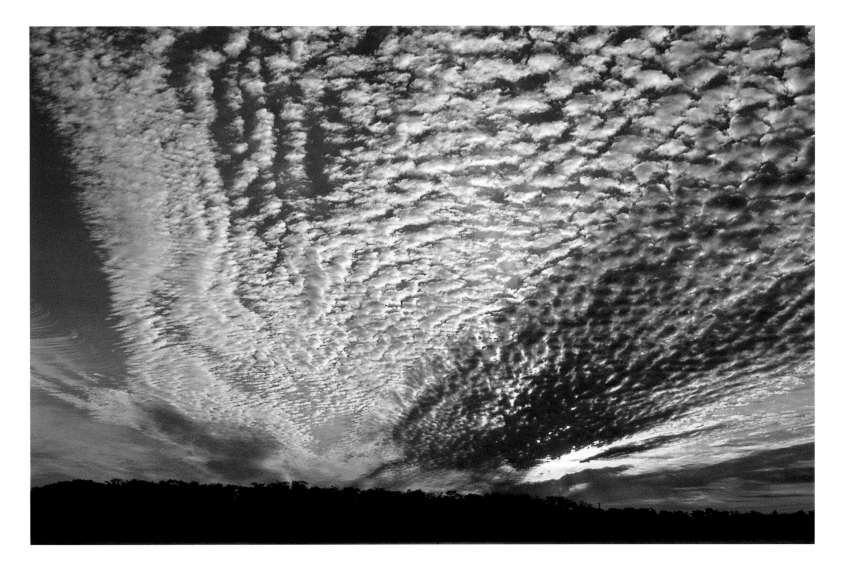

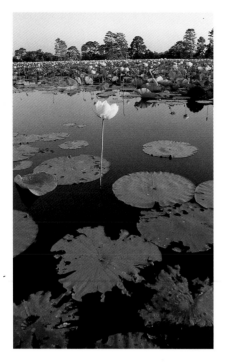

America's wetlands were created by the only major deltaic process in the lower forty-eight states and one of the largest in the world. The Mississippi River has carried a gift of earth from two-thirds of the United States and two Canadian provinces, laying down about eight thousand square miles of wetlands over the last six thousand years, stretching from the Sabine River on Louisiana's Texas border to the Pearl River on its border with Mississippi. This vast wetland not only encompasses 40 percent of the nation's marshland but is the heart and soul of the hot, spicy, fun-loving culture of the Louisianians who were hardy and creative enough to live in this semitropical wildlife paradise. We call these people Cajuns or Creoles, but they are just good people who came from France, England, Spain, the Caribbean, Africa, and many other places around the world. The hardships these pioneers faced and the ways they adapted to this steamy swampland that no one else seemed to want formed the roux in the gumbo that is Louisiana.

Now almost 25 percent of that productive but fragile gift of land is gone, and more is going. Though much of that land was donated by the heartland of America, the donation has been repaid many times over to each and every American. Whether you live in Boston or Bakersville, whether you eat crawfish or chicken, you have Louisiana to thank for it. ("Chicken?" you ask. Yes, it's the fertilizer that comes from an oily little fish called a pogie that helps keep down the price of chicken.) It might be the jazz, blues, or zydeco music you listen to or the natural gas that travels all over America from a pipeline hub in south

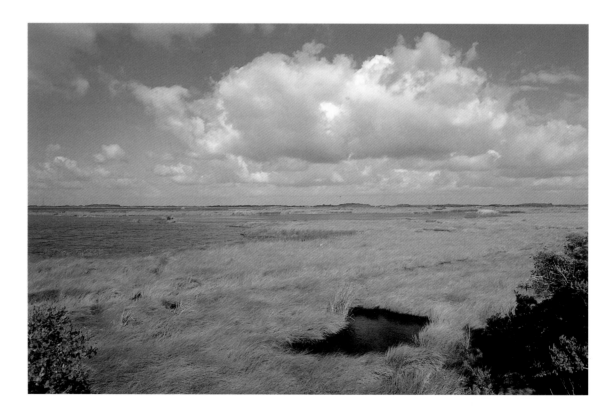

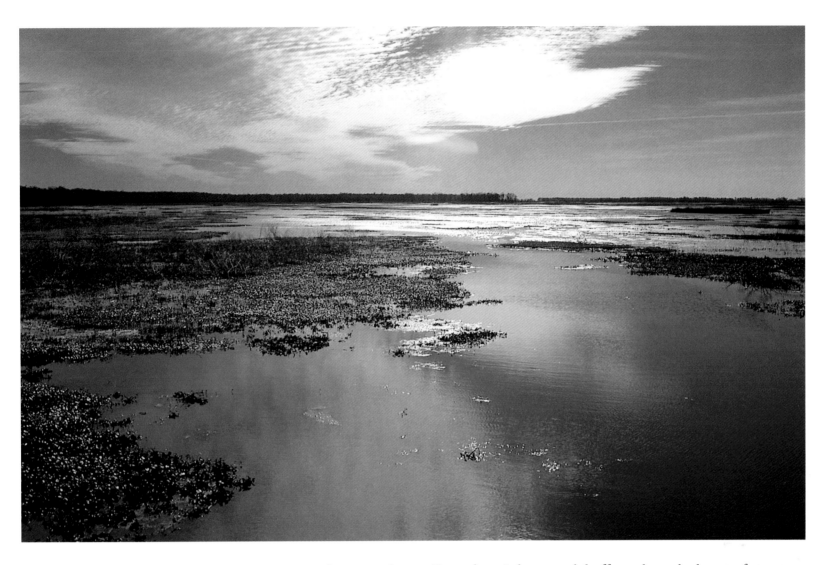

Louisiana to heat your home. Since there is less marsh buffer to bear the brunt of storms, even those pipelines are at greater risk because of coastal erosion, as they are now threatened not just by hurricanes but also by lesser tropical storms. The same might be said of the city of New Orleans, an American cultural treasure in itself. With the marshes ever receding, the city below sea level is in ever greater peril.

To me as a nature photographer, it would be enough to save the wetlands for the pelicans, porpoises, egrets, and alligators. But I hope this book helps people see that it goes far beyond that. To save this paradise, we—all of us—need to join hands and chip in to garner the dollars, the resources, and especially the courage needed to stem the tide of the wetlands' vanishing.

Marsh Mission

RHEA GARY

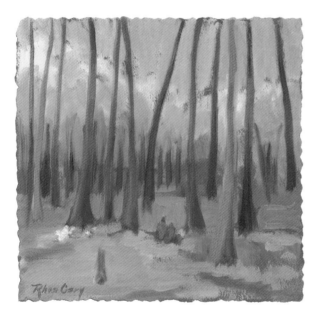

While driving along Bayou du Large back in the early 1980s, I was stunned by the sight: mile after mile of dead cypress trees, gray and skeletal against the bright afternoon sky. I kept driving, but still they were there, like a gaunt and endless assembly of silent pickets watching me pass by. I was in shock. Bald cypress is the treasured official state tree of Louisiana, and I couldn't imagine why these had been allowed to die. Once home I called my husband's brother, Don, who teaches physical geography at Nicholls State University, and described what I had seen. He was all too familiar with this problem and told me, "Saltwater intrusion by Hurricane Betsy in 1965 was what did them in." He told me about the canals that, for over forty years, have been dredged through Louisiana's coastal marshes to accommodate navigation and growing industry.

Over time, storm surge waves and the wakes of continual boat traffic have gnawed at the exposed edges of the marsh. As the marsh eroded and crumbled under the relentless attack, open water took its place. Ever-widening canals have become superhighways for saltwater intrusions from the Gulf of Mexico into interior swamps and marshes, killing cypress trees and other freshwater plants. However well intentioned, levees built along our major rivers to protect lowland communities from flooding now channel sediment-laden water straight to the Gulf of Mexico, bypassing thirsty freshwater marshes that were once nourished by seasonal river deposits.

Shortly after I learned the fate of the cypress trees, my husband, Leon, and I were

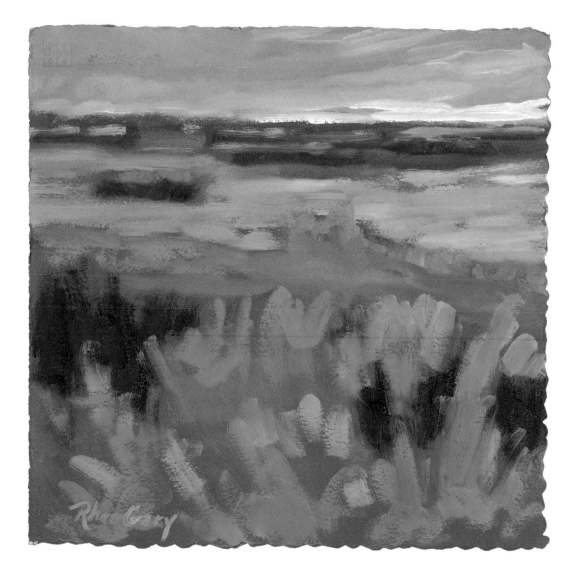

driving to Grand Isle, where we had once owned a beach camp. We hadn't been there in several years, and as we neared the island and started over the elevated Leeville Bridge, I asked him to drive slowly. I wanted to experience once again the awe evoked by the panorama of unbroken salt marsh I thought we would be seeing. But when we reached the top of the bridge, I gasped in disbelief. The marsh had simply vanished. As far as I could see, there was little left but open water.

Perhaps everyone has had such moments of insight—the sometimes excruciatingly painful realization in which one's perception of reality is completely changed. I've heard it called a "watershed moment." My awakening, brought about by these two experiences, came when I realized that the beautiful coastal wetlands—the swamps and marshes that formed the core subject of my work—would soon disappear and rot into a gray death, like the cypress forest and marsh slowly sinking into oblivion beneath the water's surface.

My first reaction was anger at the profound loss of land and natural landscape beauty. I knew I wanted to do something to help reverse this situation, but I had no idea

what that could possibly be. So I decided to learn everything I could about the causes and consequences of wetland loss. I read, I searched the Internet, and I talked to people. Two immensely helpful books were *Holding Back the Sea* by Christopher Hallowell and *Bayou Farewell* by Mike Tidwell. The more I learned, the more appalled I became.

In the last fifty years more than 1,500 square miles of Louisiana's coastal wetlands have disappeared. By 2050 another 1,000 square miles will be gone if the loss rate isn't slowed down. Scientists estimate that 30 square miles of wetlands are lost each year, an area equal to 21,000 football fields. I remembered how vast the sweep of a football field seemed when I was a high school majorette. A loss of 21,000 times that area every year was inconceivable to me. What would happen to Louisiana's coastal communities,

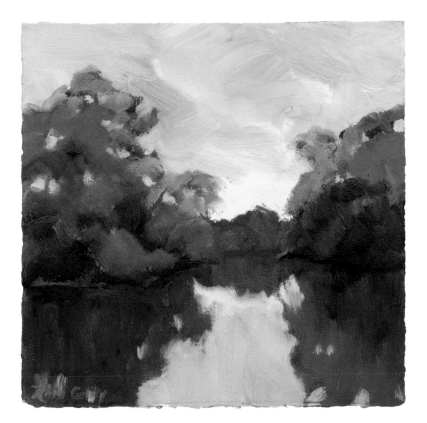

fisheries, wildlife, and, most of all, the people who had lived and worked in the coastal wetlands for generations?

Of course, far more than land is at stake. Louisiana's coastal marshes are nurseries for larval fish and shellfish. Our marsh sanctuary enables them to develop in a protected environment before they migrate offshore into the harsher waters of the Gulf of Mexico. Without marsh nurseries, these marine species couldn't survive their early stages of growth. In coastal Louisiana, where many livelihoods depend on renewable marine resources like shrimp, crab, and oysters, the seafood industry is threatened with collapse, and its workers will be forced to seek different jobs or leave. Because Louisiana's waters produce a third of the fish and shellfish harvested in the lower forty-eight states, the rest of America would also feel the effect of this profound loss.

An entire ecosystem is disappearing. Migratory waterfowl, wading birds, alligators, and furbearers will be robbed of shelter, food, and nursery habitat. The continuing death of inland cypress-tupelo swamps means the loss of nesting and roosting sites for Louisiana's majestic bald eagles and other raptors, as well as rookeries for wading birds such as ibises, egrets, storks, and roseate spoonbills. The disappearance of barrier islands will drive out the brown and the white pelicans, both of which winter on these desolate outposts. The great variety of recreational opportunities provided by wetlands for anglers, hunters, and boaters will cease to exist.

I was amazed to learn that 17 percent of America's oil and 25 percent of our natural gas come from Louisiana's offshore waters. According to the America's Wetland Campaign to Save Coastal Louisiana, more than 25 percent of all oil and gas consumed in this nation

travels by tanker, barge, or pipeline from Louisiana's shore to points all across the country. Homes are heated and cooled and lights come on in Boston, New York, Miami, and almost everywhere in between with fuel that begins its journey off Louisiana's coast. But without sustained wetlands and barrier islands to buffer wells and pipelines against the fury of hurricanes and severe storms, oil and gas extraction facilities would be subject to severe damage, and we would risk long periods of production interruption.

The state of Louisiana is deep in a desperate battle to save what remains of its wetland heritage. Giant freshwater diversion structures have been built to deflect Mississippi River water and sediment into coastal bays and wetlands. Storm-damaged barrier islands are being rebuilt while marshes are replanted with native species. But I was frustrated that Louisiana residents seemed so ill-informed and uninterested in the environmental

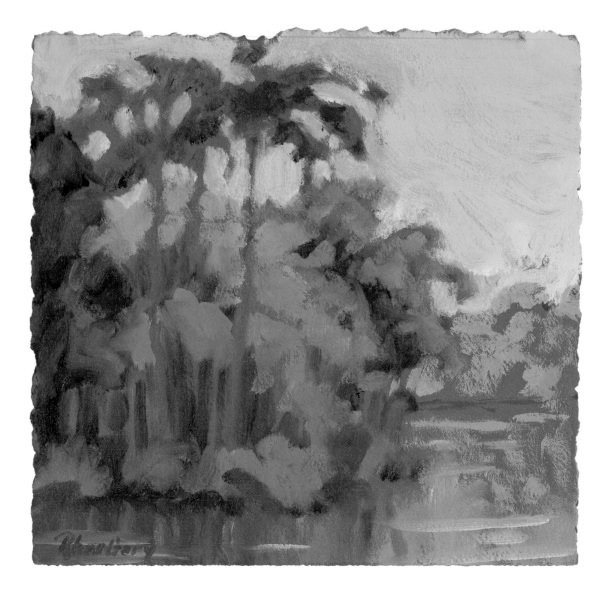

calamity we are facing. Perhaps because the problem was so vast, many who did understand the consequences were simply living in resigned acceptance of what seemed inevitable.

Was it possible for only one person make a difference? I thought that there must be something I could do, some contribution I could make, no matter how small. I thought and prayed, and it struck me that while I had seen plenty of scientific books on wetland loss, only two—the ones I have mentioned—appealed to nonscientists. Somewhere deep inside I knew my paintings could speak to regular people. Perhaps through art I might reach community leaders—the bankers, attorneys, and businesspeople who have influence and spearhead civic projects. I could share with them visually the magnificence I saw and felt in the wetlands, stun them with the prospect of losing such a treasure, and inspire them to support restoration efforts. This might be achieved in part through a portfolio of my wetland paintings in the form of a coffee table book, but I knew that alone wouldn't be enough.

C. C. Lockwood's name kept coming to me. Although I hadn't met him, I was familiar with his work and knew that this outstanding outdoor photographer could give such a book the added scope and variety it needed. Soon I had the opportunity to meet C.C. and describe my idea: two interpretations of Louisiana's wetlands through his photographs and my paintings.

When we shared our visions for this book, we saw that the project could be much more comprehensive than simply an art book. C.C. and his wife, Sue, had always wanted to spend a year on a houseboat in the marsh, and this project would give them that opportunity. We could share the boat for the purposes of painting, photographing, and gathering information that could be used in an educational program for Louisiana schools through a wetlands Web site. Sue, an adept teacher, would take a year off from teaching and coordinate the classroom activities. We would have school art and essay contests, publish an Internet journal describing our progress, and mount a traveling national exhibit of paintings and photographs. Fortunately, we were able to excite a number of research and educational groups that enthusiastically gave us grants for the unfolding project.

All of this has happened over the past year, and it has been a grand adventure. The houseboat and its support vessels have traveled many hundreds of miles on bayous, canals, and rivers throughout coastal Louisiana. Schools from across the country have participated in our wetland educational program, and an exhibition at Louisiana State University displayed the wonderful wetland art produced by the students.

I was especially touched when the mother of a student told me that her son had disliked school until his class started the wetland education project. "Now," she said, "he can hardly wait to get there every morning." CBS television filmed the project. The *Dallas Morning News, New Orleans Times-Picayune,* and other newspapers sent writers and pho-

tographers. Articles were published in *Louisiana Life, American Artist, Heartland Boating,* and other magazines. Our focus has always been to draw the same kind of national attention to America's need to restore Louisiana's wetlands that was generated to restore the Florida Everglades. We want people everywhere to understand that Louisiana's wetlands are truly America's wetlands and that our loss is more importantly the nation's loss.

Most exciting for me, of course, were the days I spent moving about in the wetlands. I was fascinated by the dramatically swift changes in the landscape. One day I was on the houseboat painting and saw wonderful red swamp maples everywhere. A few days later, C.C. called me at home in Baton Rouge and said, "You'd better get back quick. Spring is here and it's coming so fast I can barely catch it." I returned immediately and everything was different, an entirely green, entirely new landscape.

I loved the early mornings just before dawn when it was so foggy we had to navigate by compass. Trees slowly took delicate shapes as the fog began to lift. A special place was Mandalay Wildlife Refuge on Bayou Black near Houma. In the very early spring, before the alligators and snakes came out, I could get off the boat and walk the narrow ridges where palmetto, oak, and cypress grew. It's a wonderful freshwater swamp. I also loved

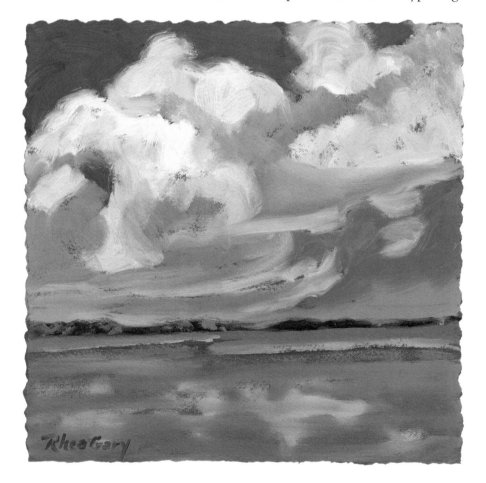

the wildlife at Rockefeller Refuge, including the songbirds that could be heard if not always seen, the rabbits scooting underfoot, the alligators sliding into the water as we approached, and the resident Canada geese and their goslings waddling beside the road. Everywhere, the variety of birds was astounding: coots, cormorants, mourning doves, snowy egrets, white pelicans, herons, swallows, red-winged blackbirds, terns, kingfishers, finches, and many others that I could not identify.

Wetland sunsets and sunrises were spectacular. I used so many sunset colors in my paintings—reds, yellows, and purples. My feelings after seeing the dead cypress trees on Bayou du Large came out in all the red I used. Red can be a very angry color, but it also blazes with courage and passion. For me, only bold colors can adequately convey what I feel and see in my mind's eye while I am painting.

I'm not interested in creating realistic scenes; I leave that to C.C. and his wonderfully

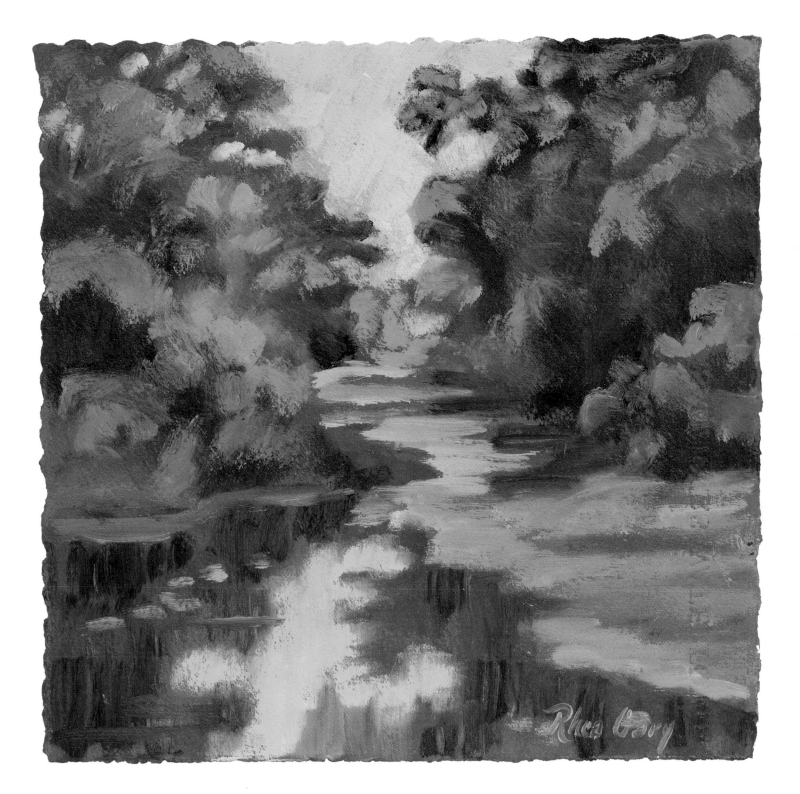

discerning eye and camera. What I try to achieve in my paintings is a certain balance between reality—a recognizable image—and abstraction. I use color to convey my own emotions, but I also want the viewer to have an emotional response.

When I started painting for this book, my husband asked how I could produce thirty or forty wetland paintings that didn't all look the same. Each area I visited, however, revealed its own special secrets and inspired different emotions. After every trip to the coast, I returned to my studio with a new vision for a unique painting.

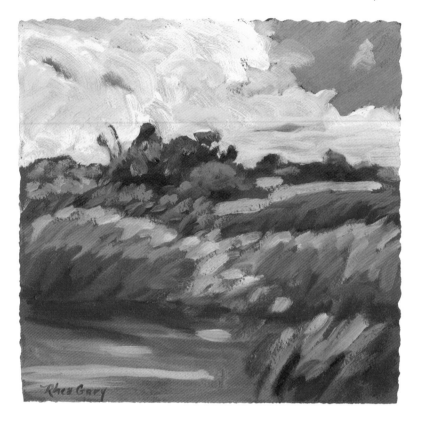

Despite the many painting trips I took down Bayou du Large, for example, I always found a different view and a new mood to emphasize. As we were leaving the dock for home one gray and windy day last winter, sunlight unexpectedly pierced the gray sky. High billowy cumulus clouds rolled in over the marsh grasses, which blazed yellow and red in the sudden new light. I had never seen the marsh and sky look quite that way before. I placed the horizon line low on the canvas, emphasizing the dramatic shapes of the clouds and the bright sky colors breaking through. My biggest challenge in this painting was to make the marsh grasses dance on canvas as they did in the wind that day.

I first started painting wetlands simply because they were beautiful. It all began many years ago when my son, David, invited me out on his boat to see Spanish Lake, where he had a duck blind and hunted in the fall and winter. I fell completely in love with the landscape. I couldn't believe the natural splendor I saw. So much of the beauty of Louisiana can't be seen except from a boat, and I had not realized that it was there all along.

I came home after that first trip to Spanish Lake and started painting for a Louisiana Archives show called "A Louisiana Love Affair." The first two paintings I did were in the cool, serene colors I had always used. They were beautiful, and I knew people would like them, but there was something missing. I sat in my studio till after midnight, frustrated, praying to see what I wasn't doing right.

All of a sudden it hit me. Louisiana is *hot*, but I was using a cool palette. If I wanted to communicate my heart, mind, and spirit's response to the wetlands, I had to paint what I really felt, physically as well as emotionally. And I had felt the heat in that boat that day. I knew I had to change my whole palette and paint from a warm perspective.

I was working on another painting that I was unhappy with, so I started slathering

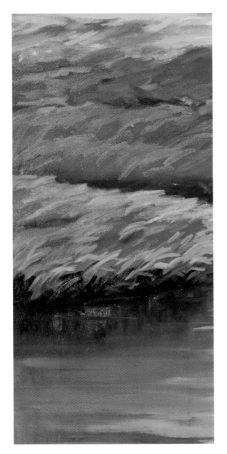

Detail from *Marsh Enchantment*

bright, warm colors over it. When I finally went to bed that night, I was pleased. The next morning I was still pleased with the warm colors, and since then I've never looked back.

As I continued to paint wetlands over the years, they became even more important to me when I realized what an integral part of Louisiana's cultural and economic history they have been. Many of Louisiana's early settlers were displaced and desperate people longing for and finding a place where they could live off the land and in peace—Native Americans like the Houma and Chitimacha, who were master fishermen; the French Acadians, who became shrimpers, trappers, and farmers; the Spanish Isleños from the Canary Islands, who set out to cultivate rice but became adept at fishing instead; the German immigrants, who were the first commercial crawfish harvesters; the Chinese, who built huge platforms in the bays on which to dry shrimp for market; and the Yugoslavians, who established Louisiana's oyster industry. All of these people contributed to the folkways, music, spiritual life, art, and traditions that characterize Louisiana today. But none of these cultures could have flourished over the centuries if it were not for the continual reinvigoration of the state's coastal wetlands.

I first came to know and love coastal Louisiana through its people, the descendants of the area's earliest settlers. I was twenty-three, just out of LSU, and working for the Louisiana Cooperative Extension Service as a 4-H program coordinator. I was sent to Houma, where, with the county agent, I visited all the schools up and down the bayous of Terrebonne Parish. These were very small, simple schools, and I could barely pronounce the children's names. Some of the schools had two first grades because the children came to school knowing only French and had to be taught English before they could learn anything else.

In Pointe aux Chenes, which was very isolated at the time, the kids were usually hanging out of the windows watching for us, and we could hear them holler, "They're here, they're here!" There was no air conditioning in those days, so all the windows were open. Every school was excited that someone from the "outside" had come, and they always had coffee and beignets for us.

These bayou people lived hard lives. But I saw in them a sweet, giving spirit; they were accepting and appreciative, and I developed a love for them. The principal at one of the schools said to me, "Chère, you drink the water down here, and you'll never leave." He was right. Although I left physically—marrying and raising a family in Baton Rouge—my heart never left. From the first time I went out into the wetlands in David's boat, I always felt renewed and refreshed, as if I had come home spiritually and artistically.

When I drove to Isle de Jean Charles, a small hamlet that straddles a narrow ridge of land whose surface is just inches above the marsh, I was reminded of my earlier years on the bayou and the hardworking people I had known there. That bright blue day, as marsh

grass rustled in the wind and the ever-encroaching water lapped against the roadway's edge, I felt as if I had entered a time warp. It was a journey deep into the past, into a hauntingly beautiful but inhospitable area that, several centuries ago, had become home to Native American trappers and fishermen. Their descendants, about 220 people, are members of the Biloxi-Chitimacha tribe within the Muskogee Federation. In 2001, Isle de Jean Charles residents were legally recognized as members of the tribe. Although great joy accompanied that recognition, the people, who have endured much hardship, now face a bleak future.

Until the 1950s, when the road was built, all travel to and from Isle de Jean Charles was by boat. Children went by pirogue to attend a small school in Pointe aux Chenes, a trip that meant paddling or push-poling four miles each way. The school went only to the eighth grade, so children who wanted to continue their education had to make a fifty-mile round trip to the first "Indian" high school in Louisiana, at Daigleville, east of Houma. It wasn't until the 1960s, when public schools in Terrebonne Parish were finally integrated, that the Native American children were allowed to attend schools closer to home.

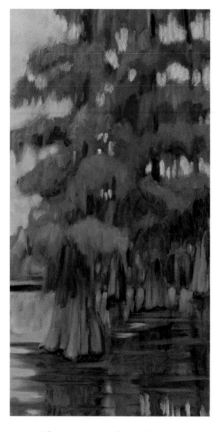

Detail from *Dressed for Fall*

As I explored Isle de Jean Charles, it was easy to see the destruction of formerly high and dry terrain—and the devastation of an ancient way of life. Large herds of cattle once grazed land that has now disappeared, and today there is no longer enough land left to raise any livestock. Gardens had disappeared because of saltwater intrusion. The houses, which were built on piers in order to escape flooding, were all at great risk.

Under a government resettlement offer, many longtime residents left unprotected by a new hurricane protection plan have had to abandon the only place they ever called home. Huge live oaks—many now dead—stood beside the vacant houses like aging sentinels pointlessly guarding something no longer there. In the distance, beyond the marsh, I saw giant storage tanks on huge oil platforms, seemingly the only things left. The grim fate of Isle de Jean Charles may also be facing many such coastal communities where the economic health of the people is firmly tied to the stability of the wetlands.

In contrast, Louisiana's western coast seemed booming with industry and tourism. I followed the Creole Nature Trail, a National Scenic Byway that in 2002 was designated an All-American Road, as it traced the shoreline through Cameron Parish to the Sabine Pass, the westernmost part of Louisiana's wetlands. Here, nature and industry seem to have reached détente, as the road allows equal access to coexisting oil industry service companies, recreational beaches, fishing piers, and two important wildlife refuges. Breakwaters and continual sand replenishment projects buffer inland marshes and provide a series of beaches for picnicking and swimming. The largest, Holly Beach, is called the "Cajun Riviera" by parish residents. At the Sabine National Wildlife Refuge, visited by 300,000 people a year, sixty-one miles of levees and eight water control structures protect brackish marsh from saltwater intrusion. I strolled on the popular Wetland Walkway, refreshed by

the long peaceful vistas over unbroken marsh and the low, rolling clouds that I knew would find their way into my next painting.

With their many faces and moods, as changeable as coastal weather, the wetlands will never lose their beauty and mystery for me, and always there are the fabulous colors. During a vibrant golden-pink dawn, the marsh is gilded and serene, promising a gentle day, but just an hour later the sky can darken and shroud the landscape with an oppressive wash of purple. I have seen it bloodred at sunset and blazing green-gold at noon. In a storm, the marsh can be crackling yellow with lightning and then turn delicately lavender when the storm is over. In the swamp, grays and greens and purples and browns blend in a gentle and soothing collage, barely hinting at the vast network of life it shelters. I have tried to capture in paint all these moods and colors to express the many ways that wetlands are indivisible with life in coastal Louisiana. I feel that I have succeeded when someone says to me about one of my paintings, "Oh yes, I've felt that way in the marsh."

Traveling coastal rivers and bayous, writing my journal for the Web site, working with the schools, and, of course, the immense amount of painting needed for this book have been a great joy for me but also humbling, as I have needed—and received—much help. I know that the Lord had His hand in this, working out details in ways that were far beyond my personal capabilities. Every morning I put my efforts in God's hands, and He was faithful. I am also extremely grateful for the constant support of my family—my hus-

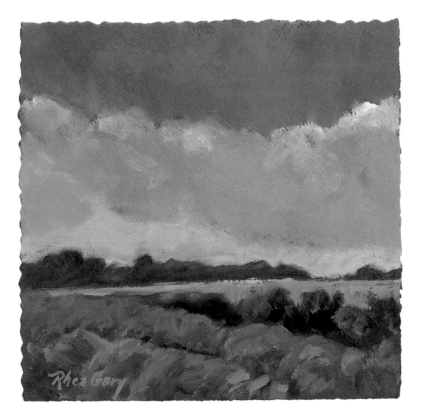

band, Leon, and my children, David, Cherie, and Emily.

Restoring America's wetlands will require untold amounts of money, innovative technology, and the concerted efforts of an army of scientists and engineers. It will be a vast, long struggle—against time, the relentless forces of nature, and the lasting impacts of human mismanagement. But we can all help in some way, perhaps by urging our elected representatives to aggressively seek restoration funds, helping to raise funds for reclamation, replanting marsh grass near our homes or fishing camps, or involving civic groups and schools in restoration projects. It is my hope that this book will help to inspire such commitments to saving Louisiana's priceless heritage. We must not fail.

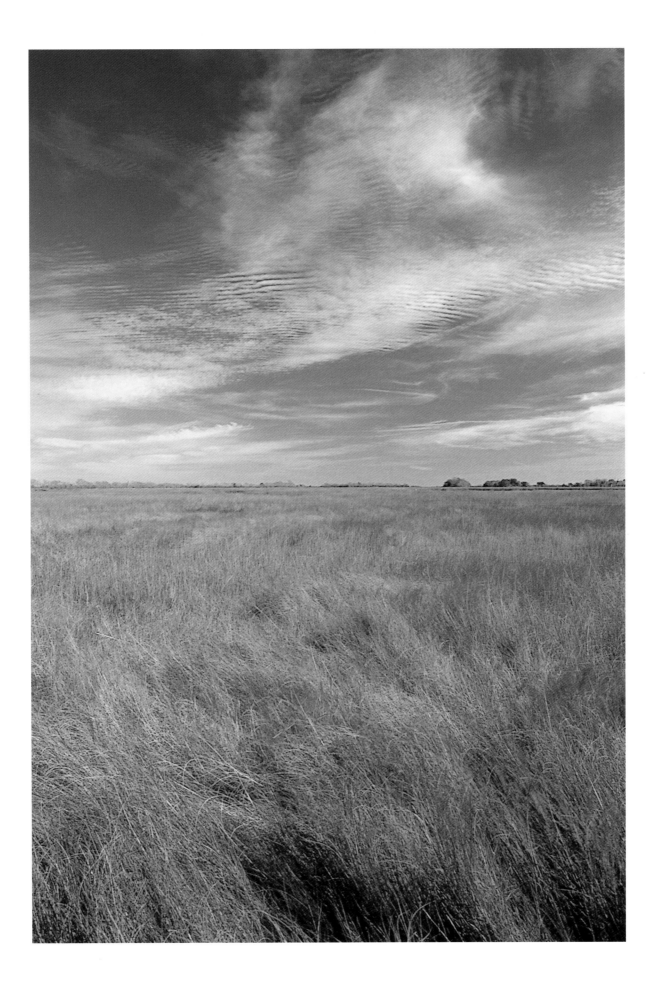

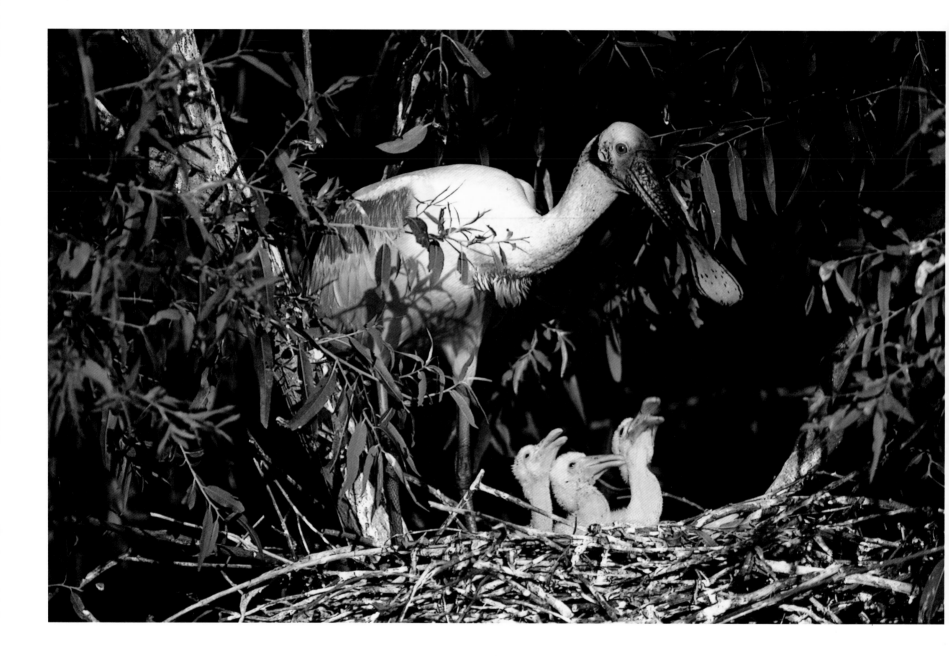

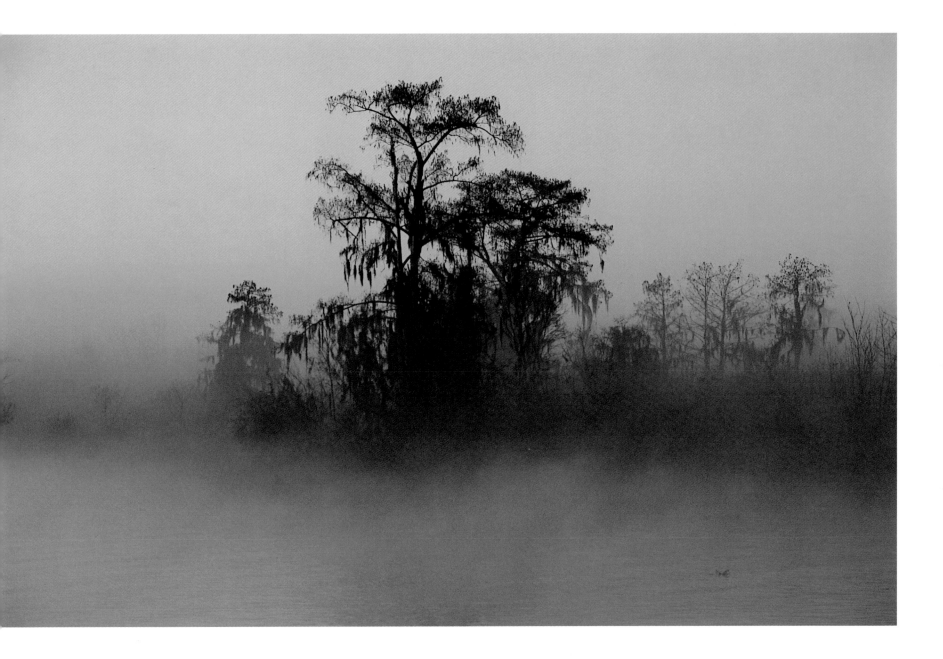

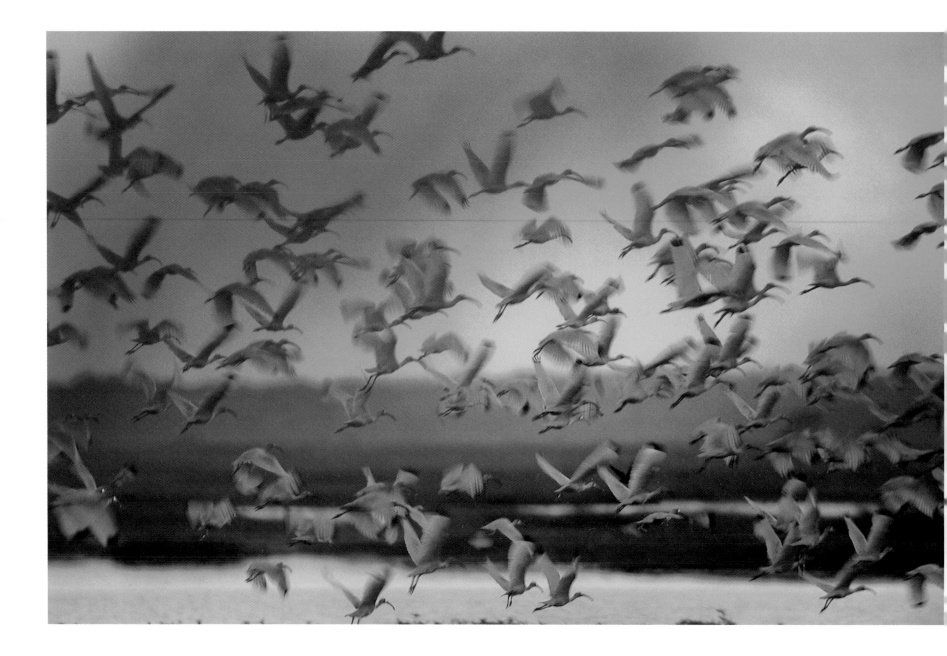

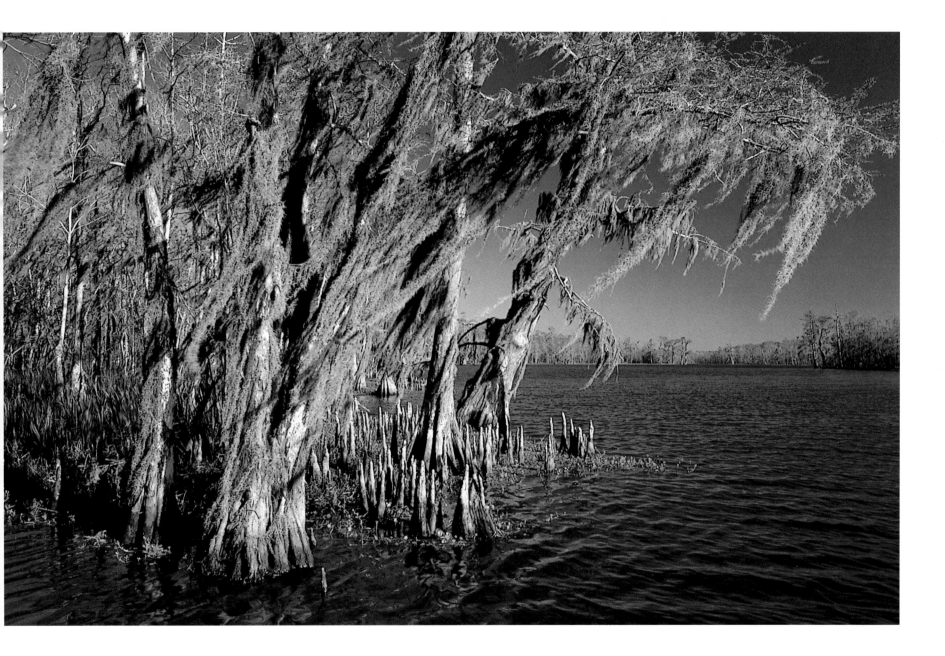

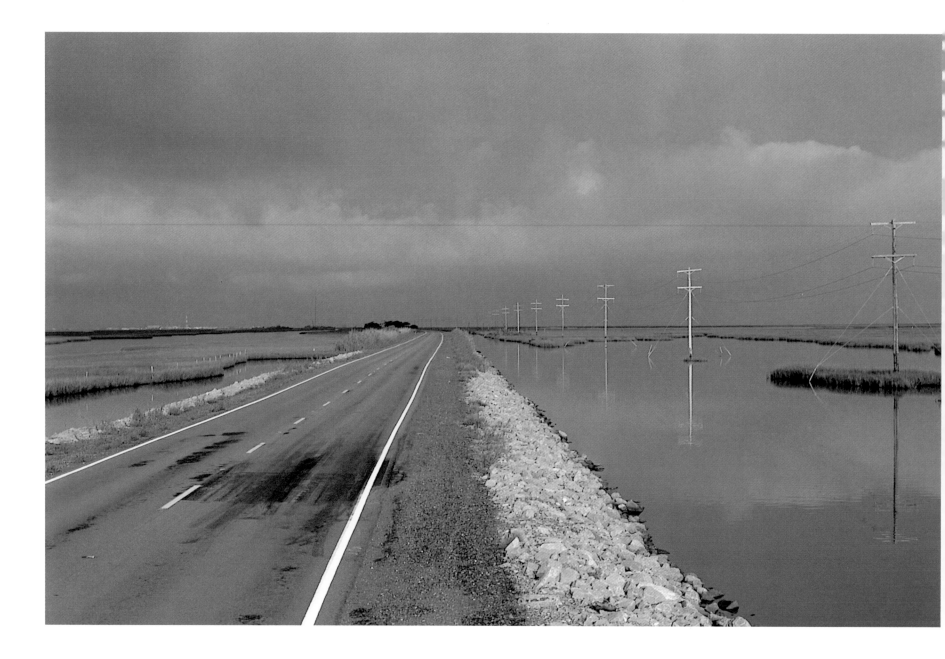

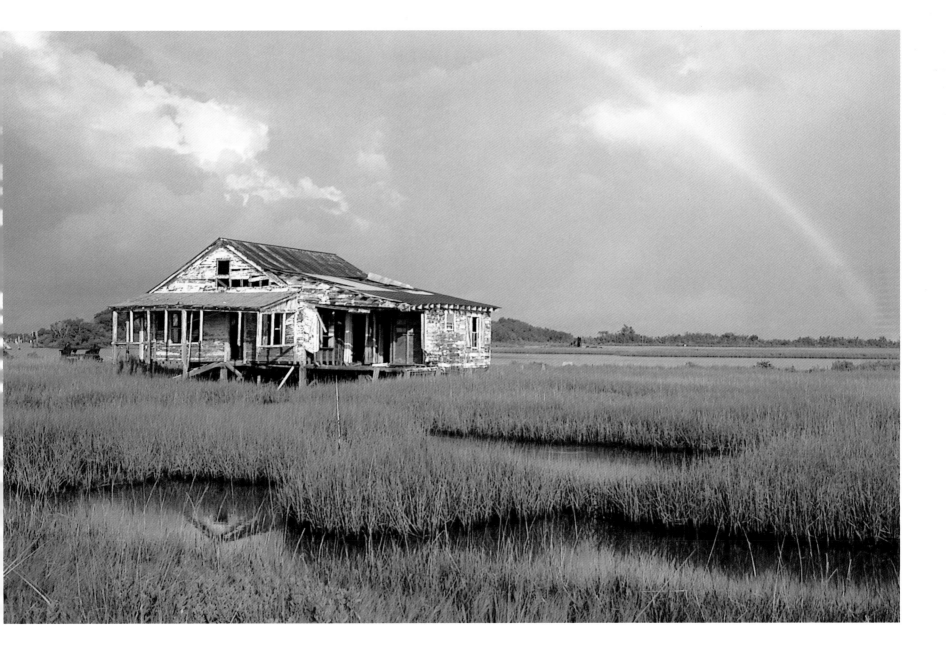

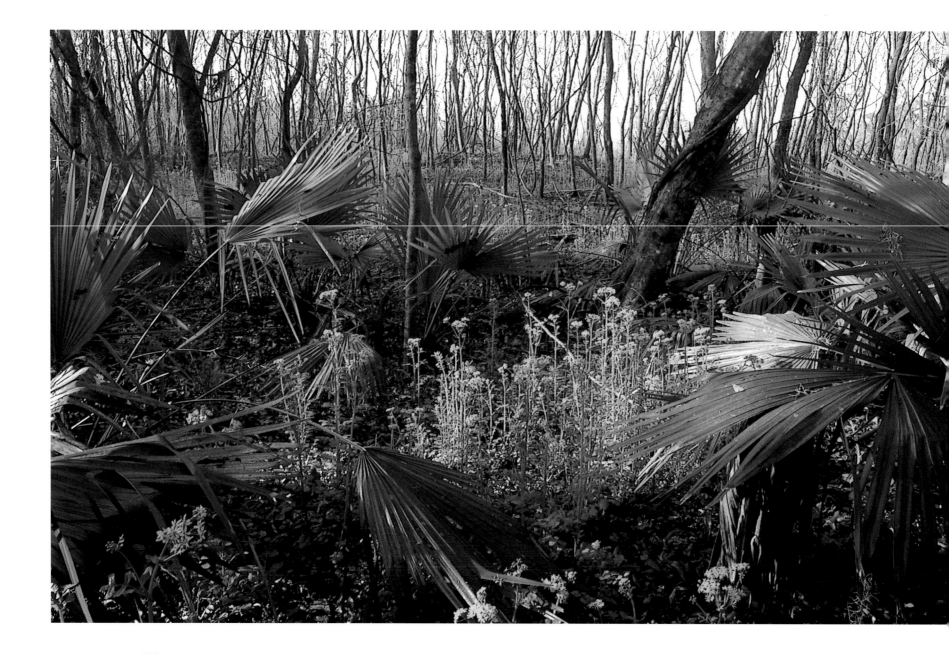

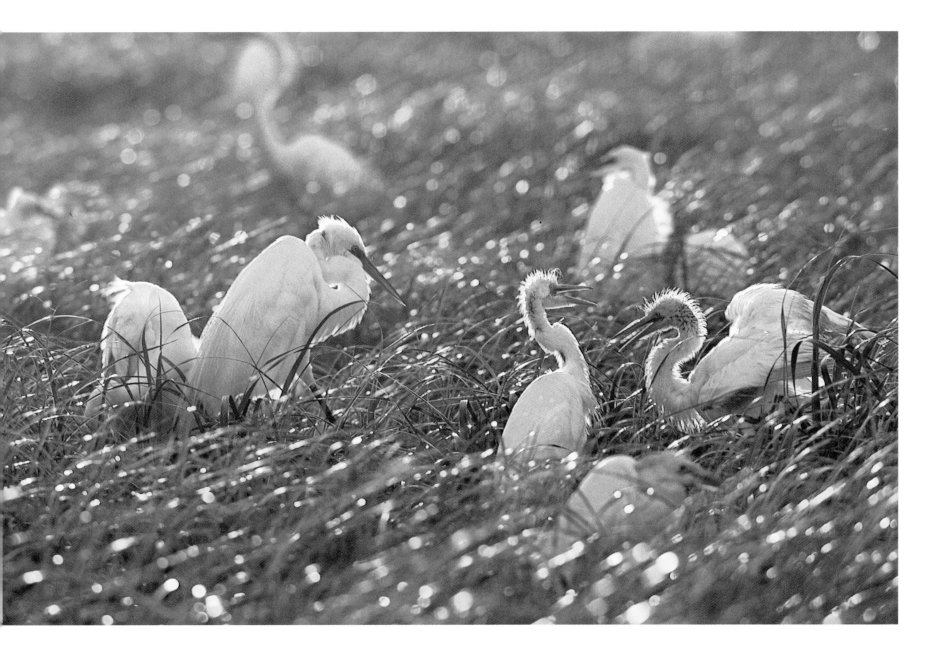

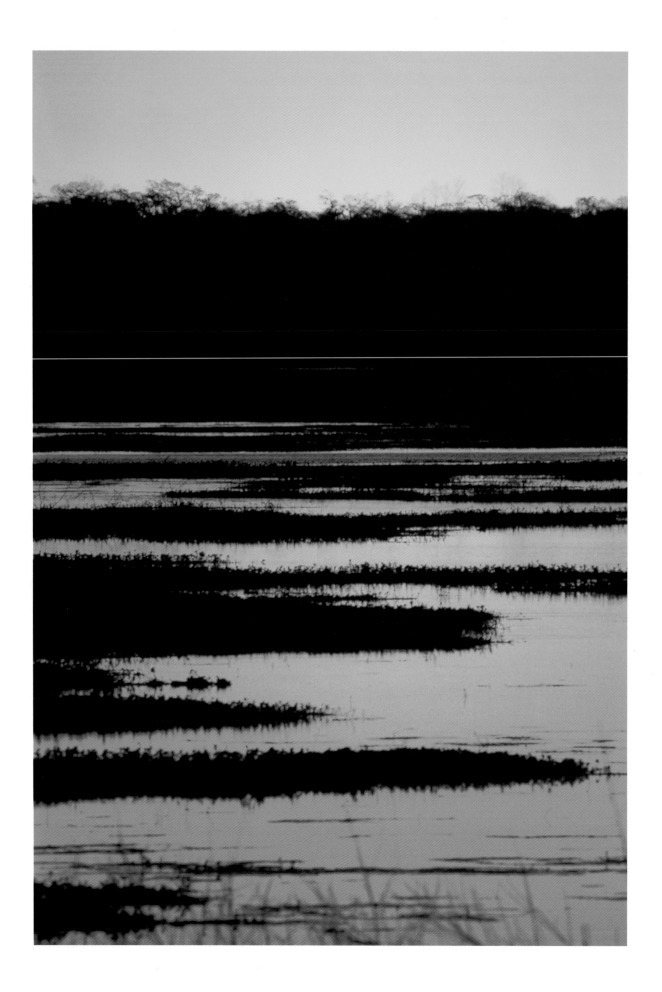

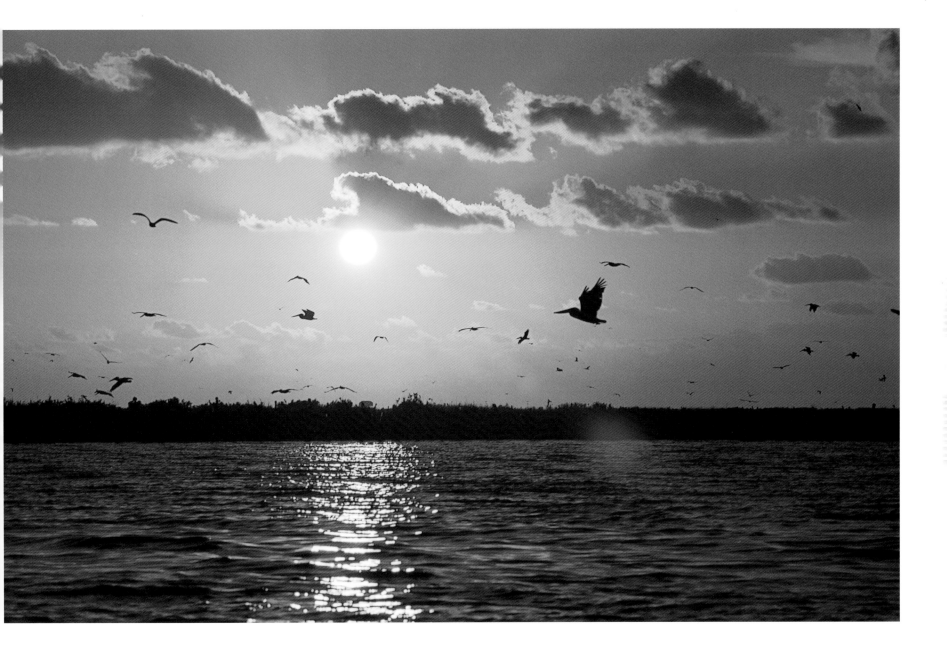

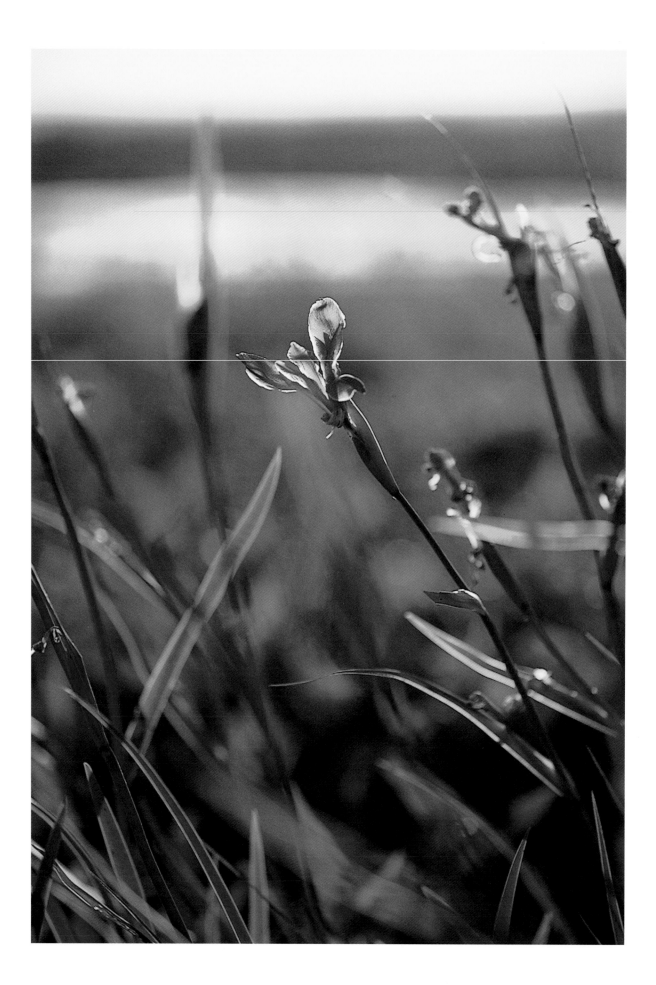

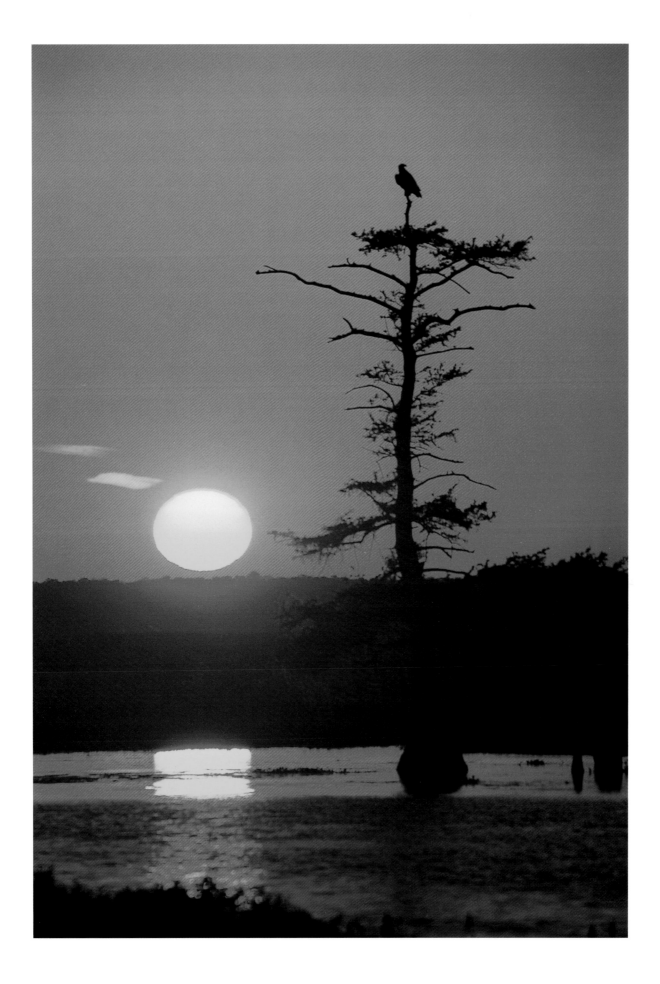

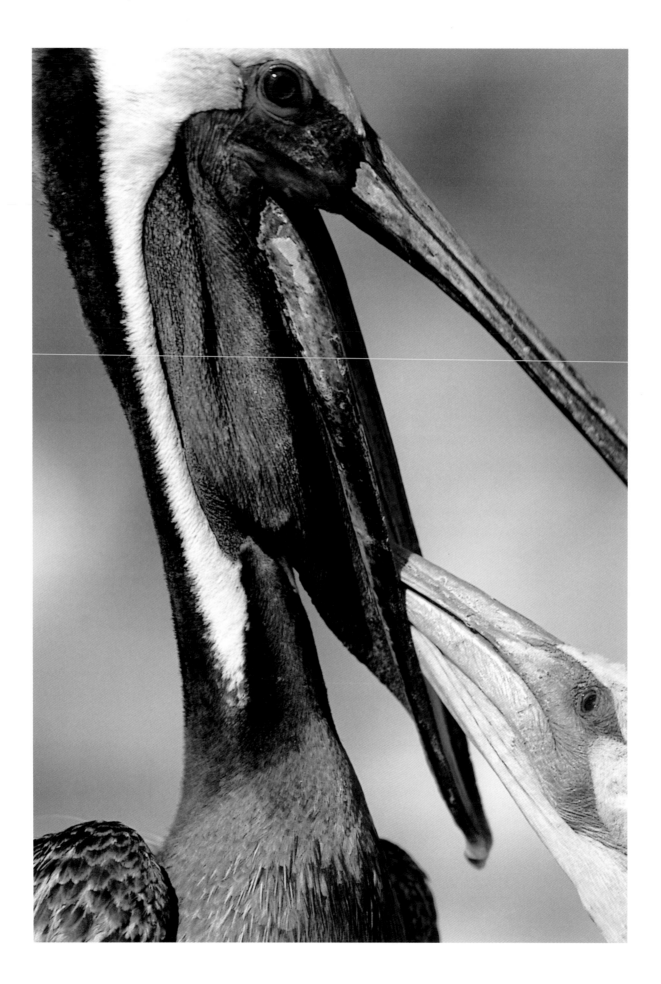

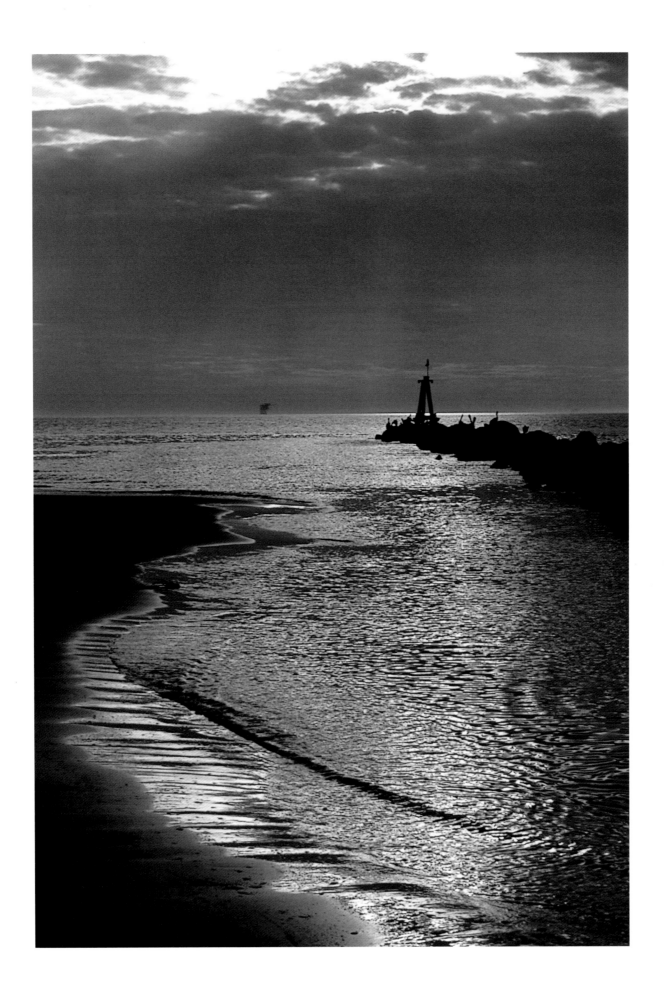

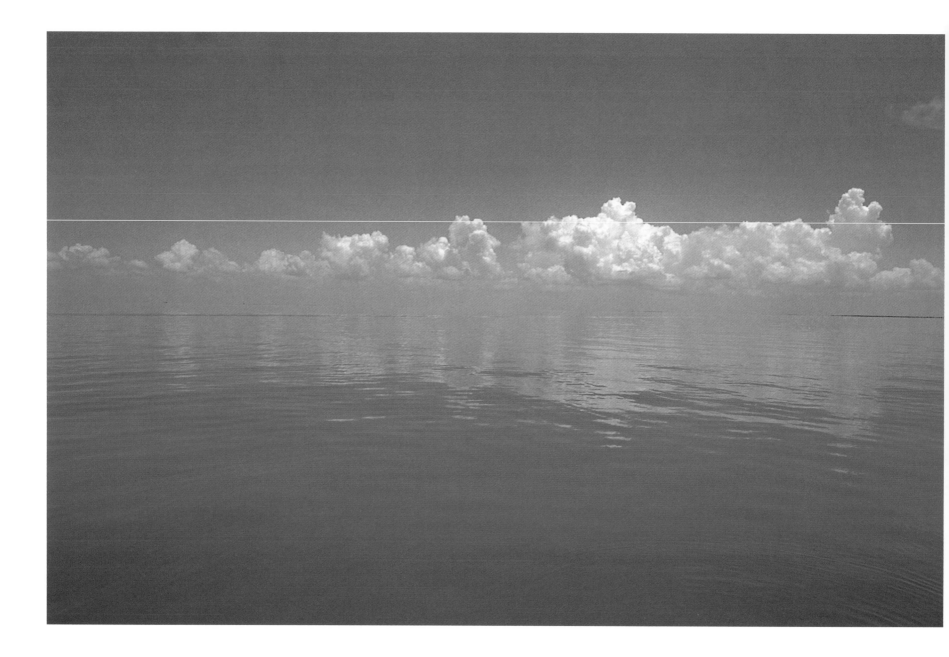

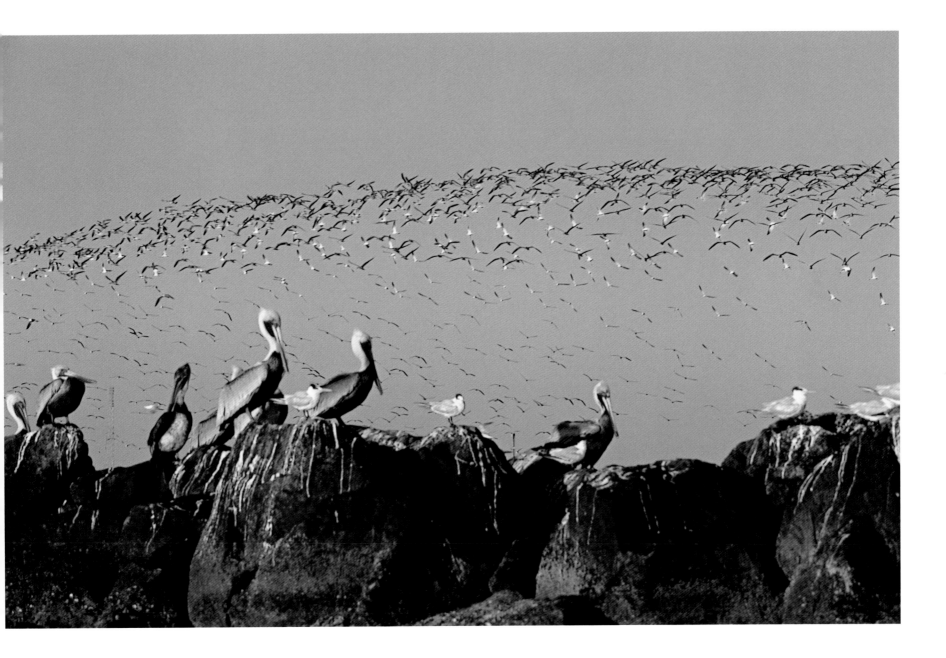

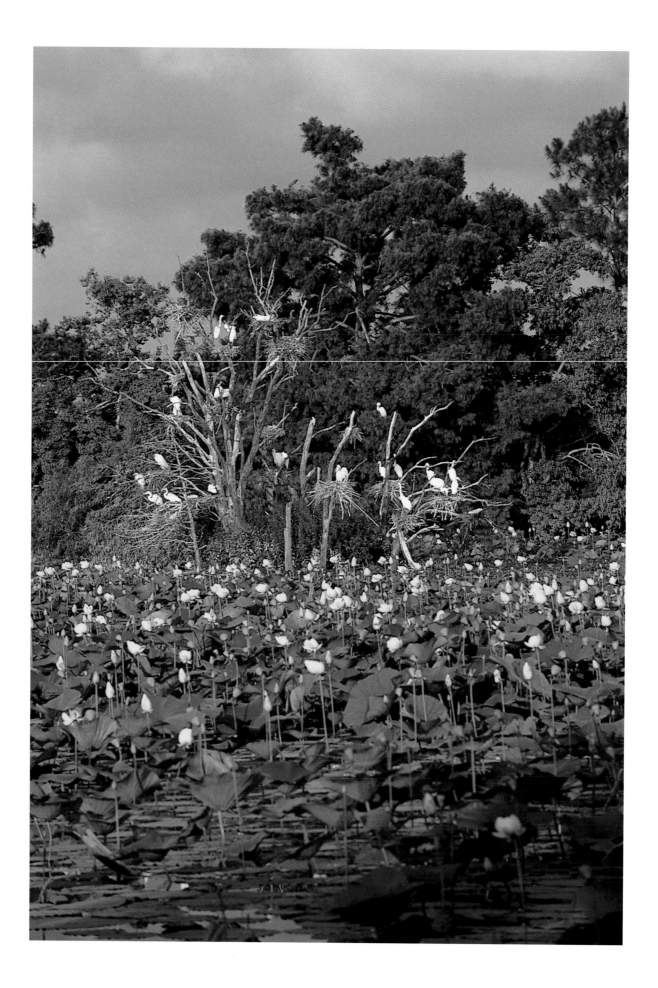

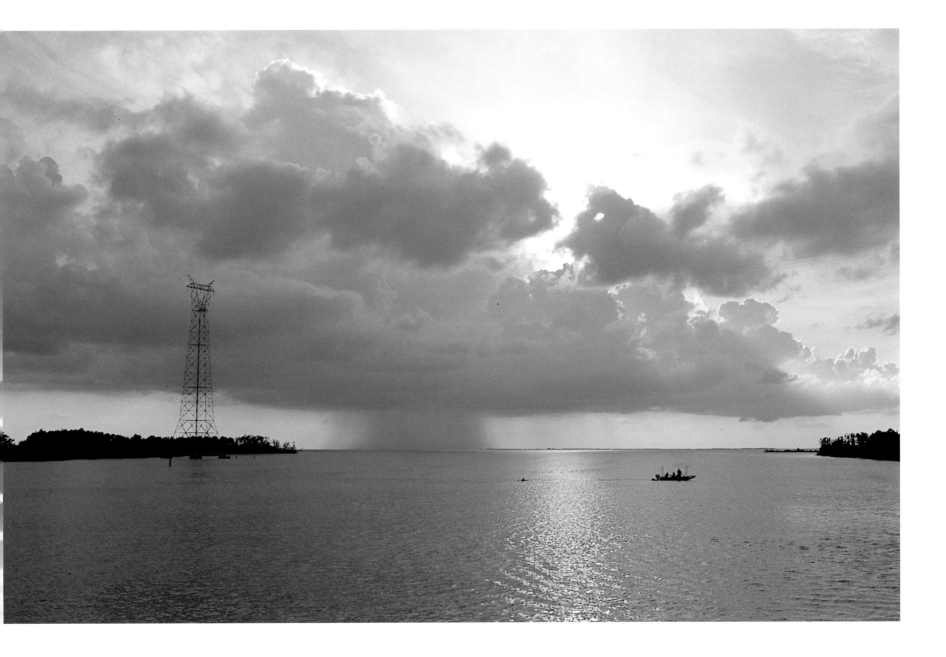

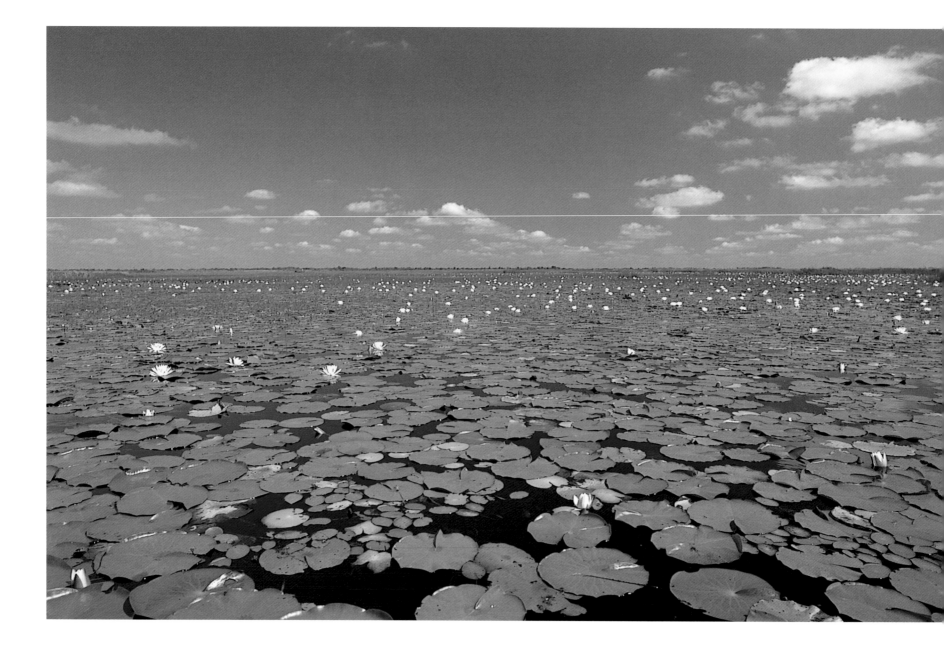

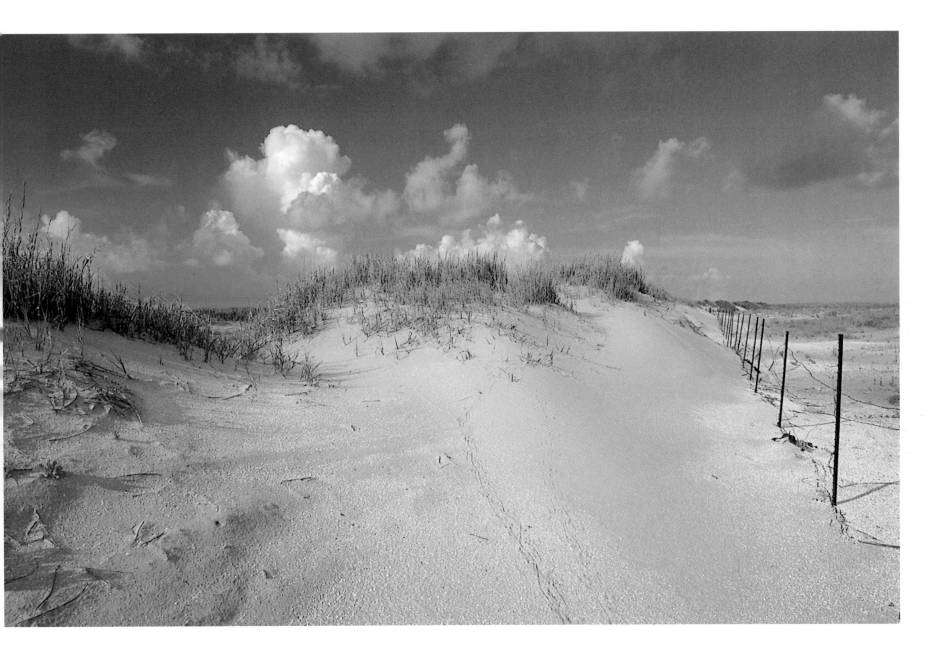

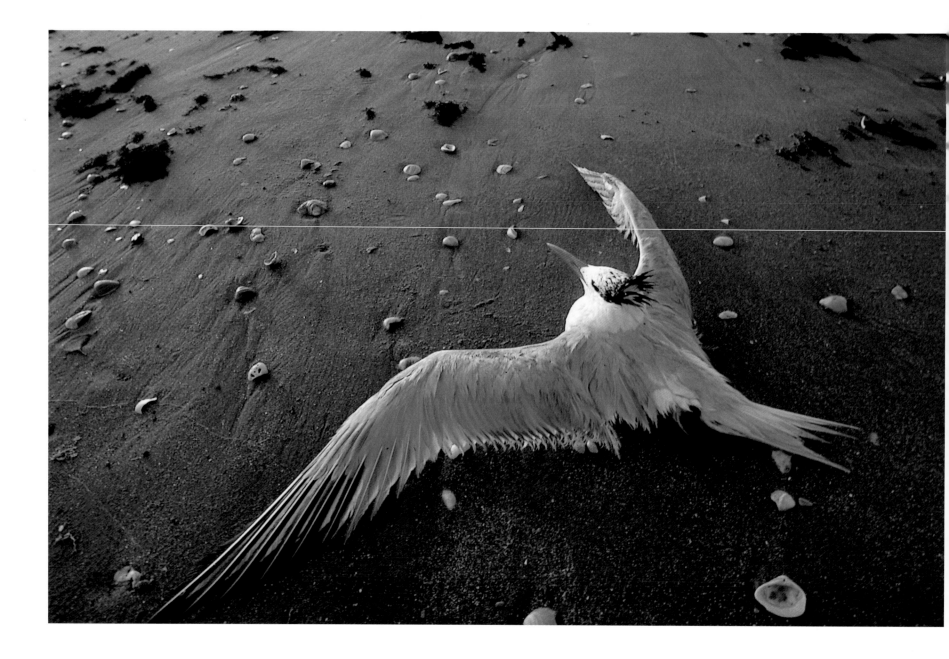

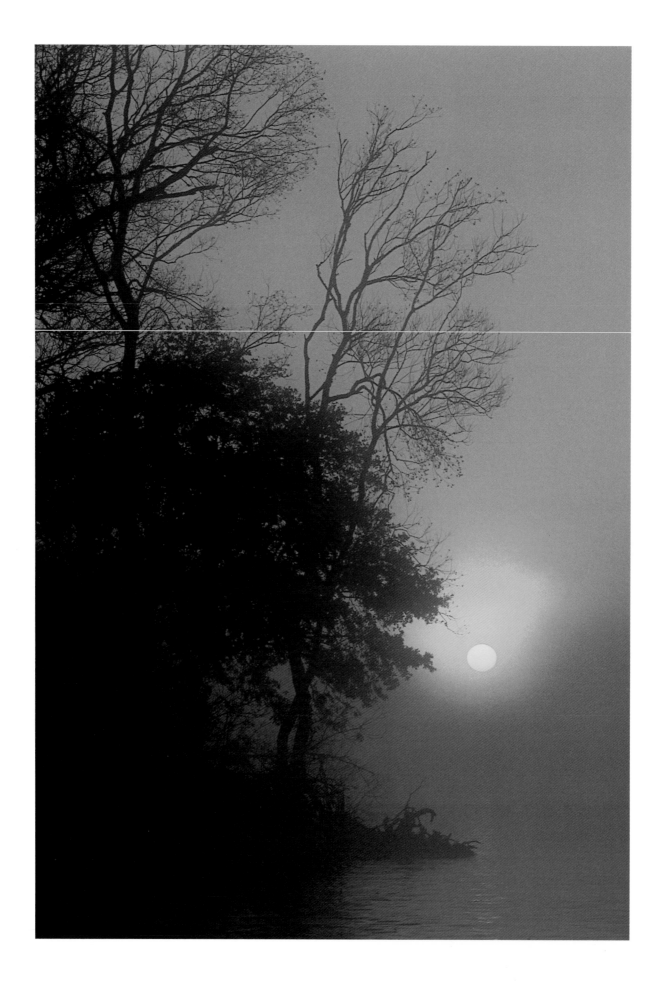

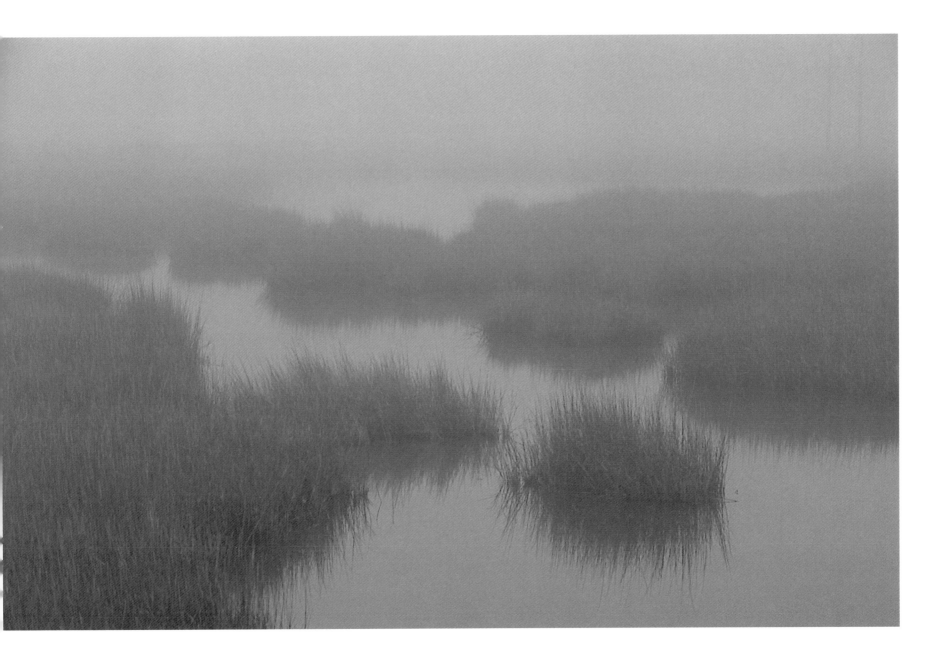

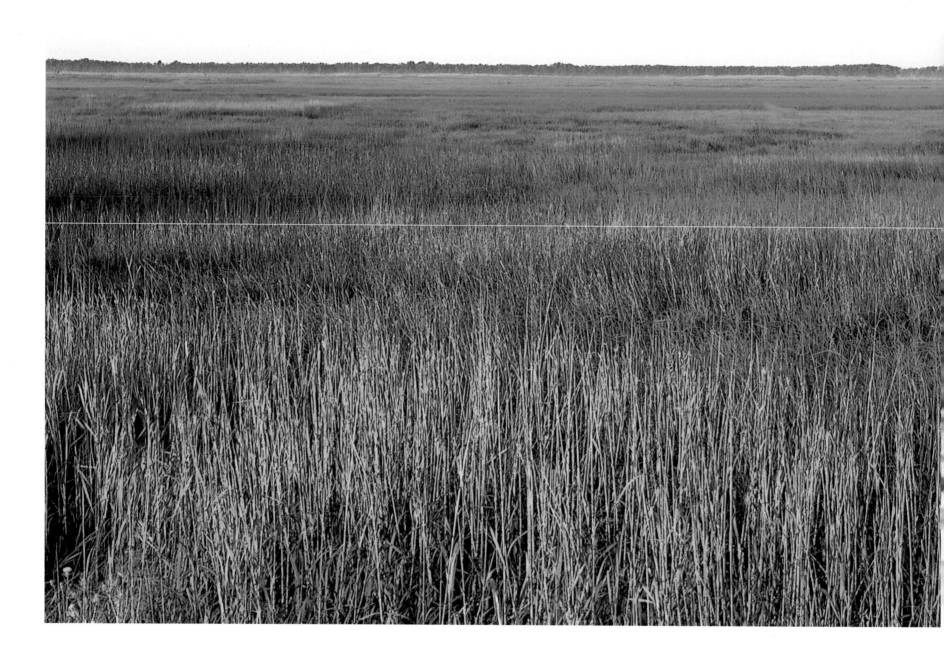

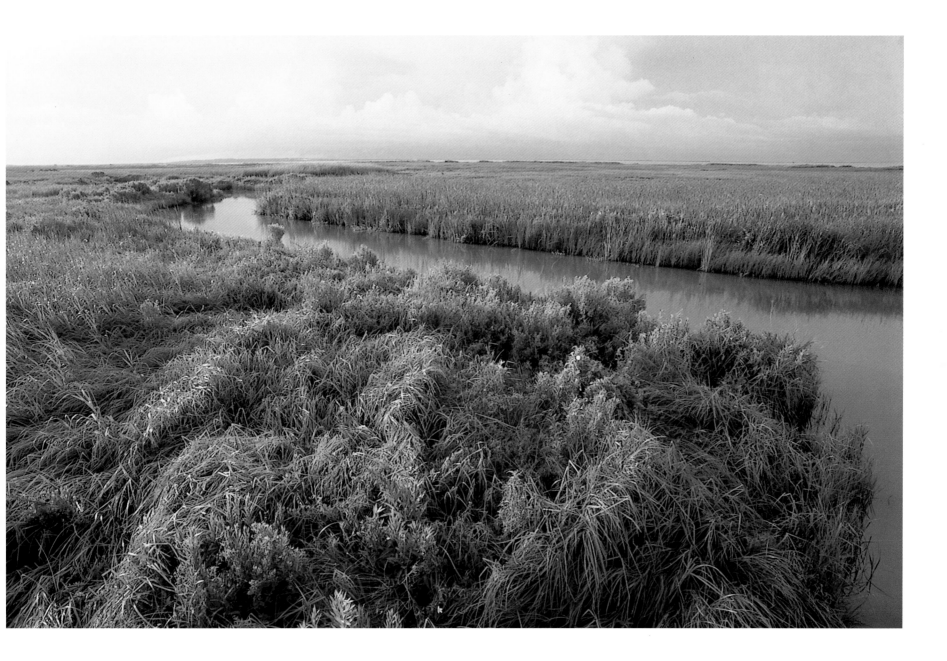

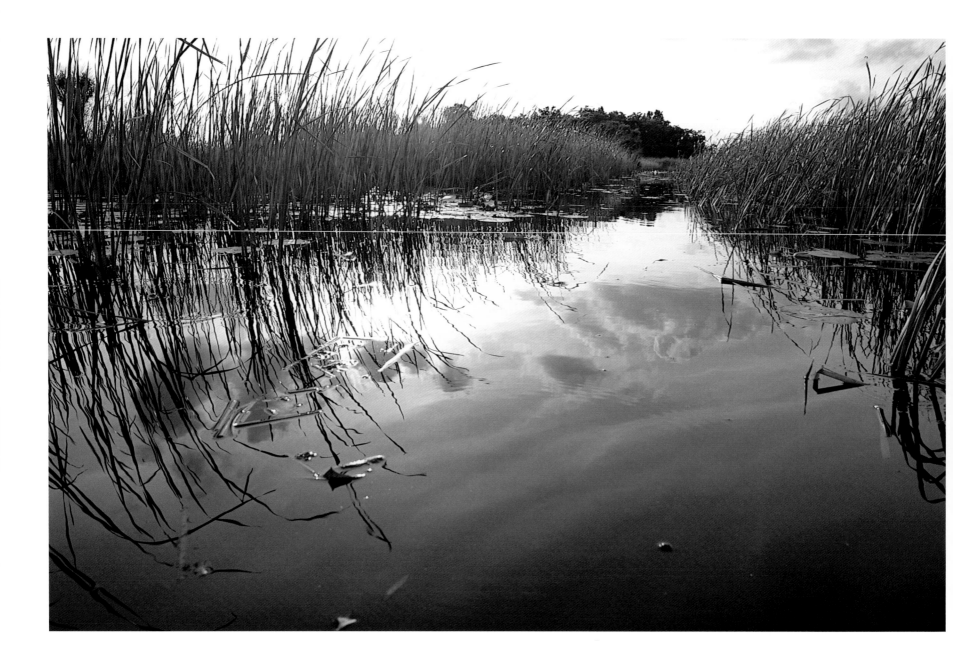

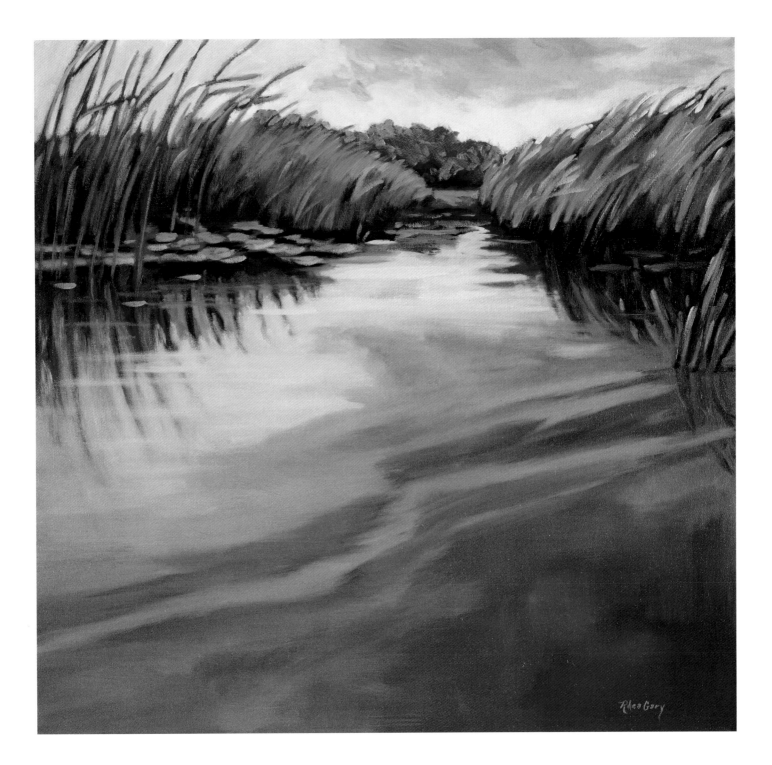

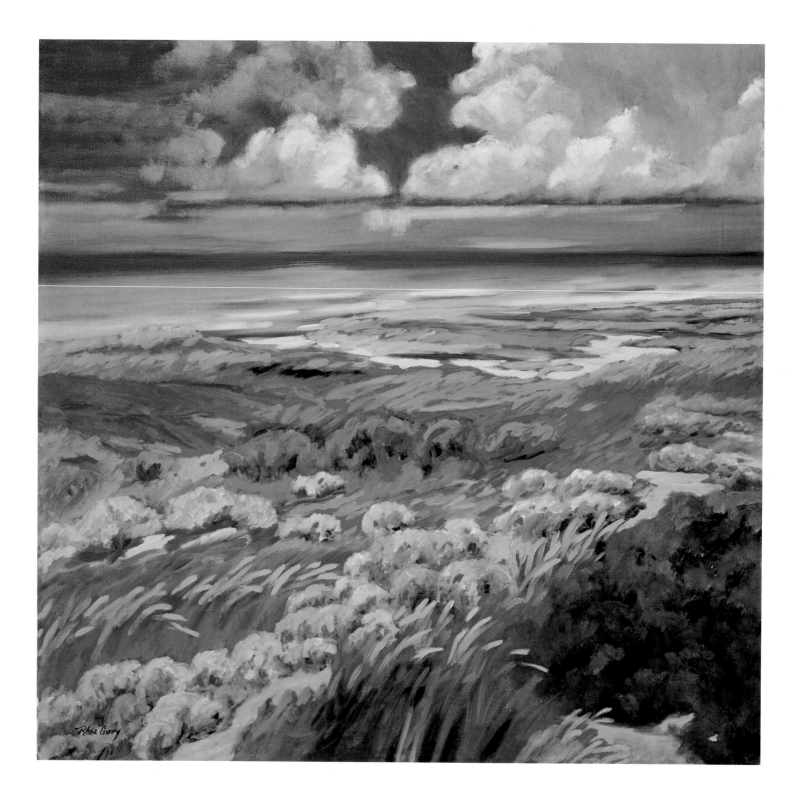

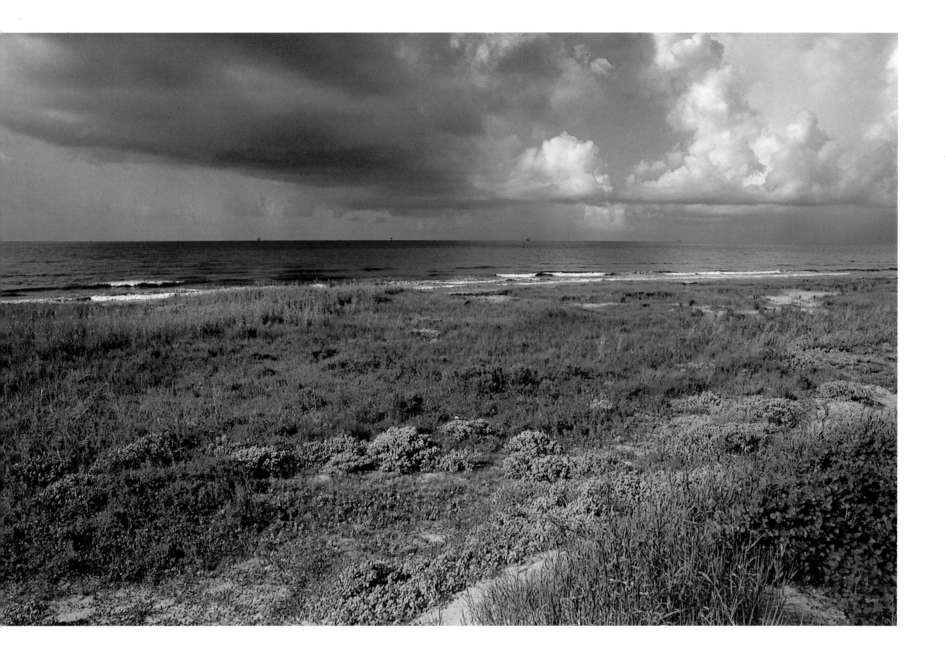

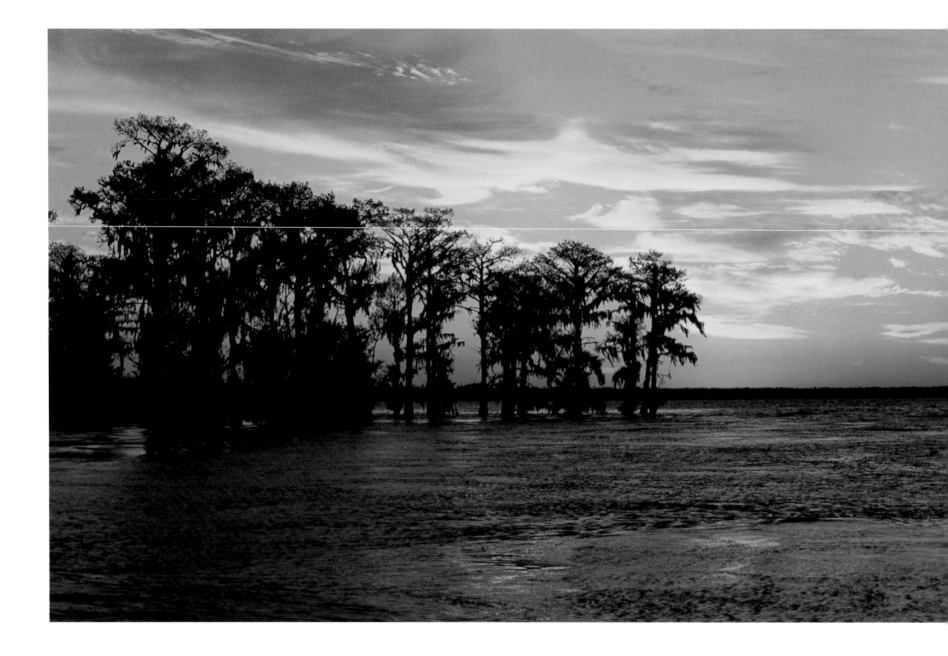

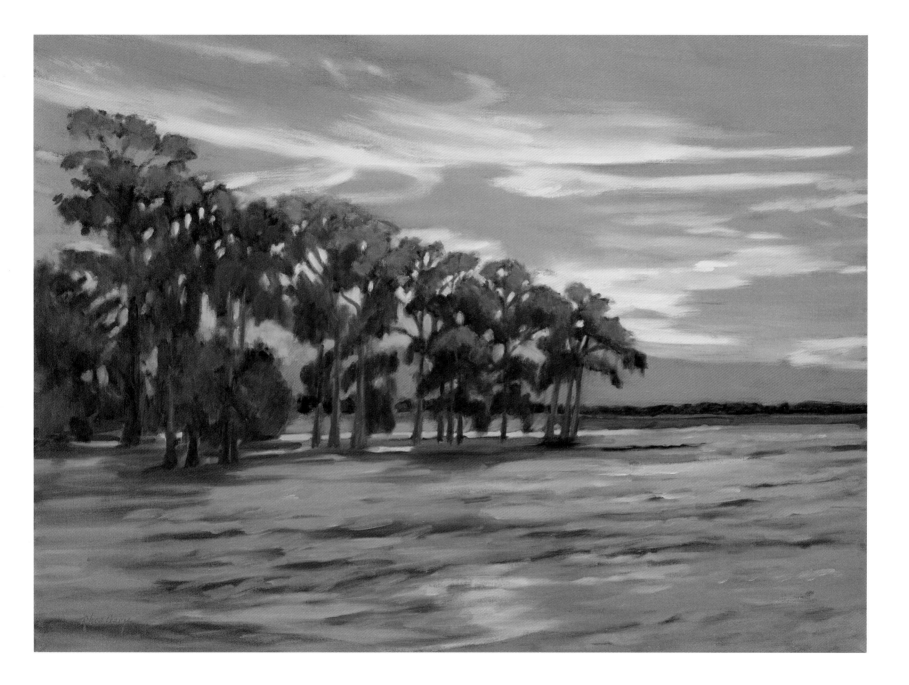

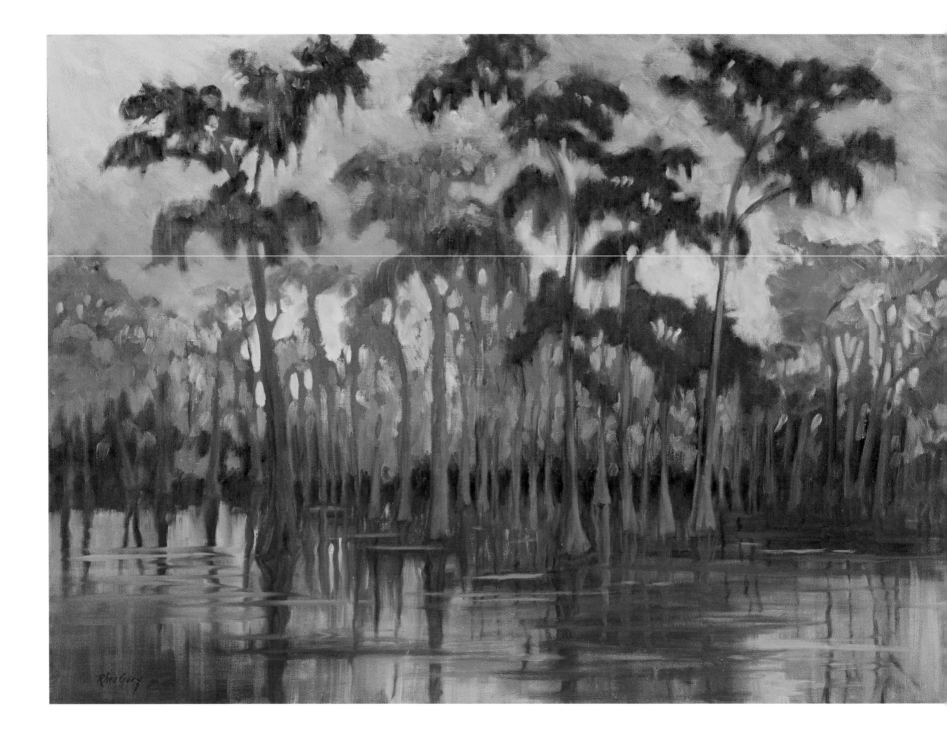

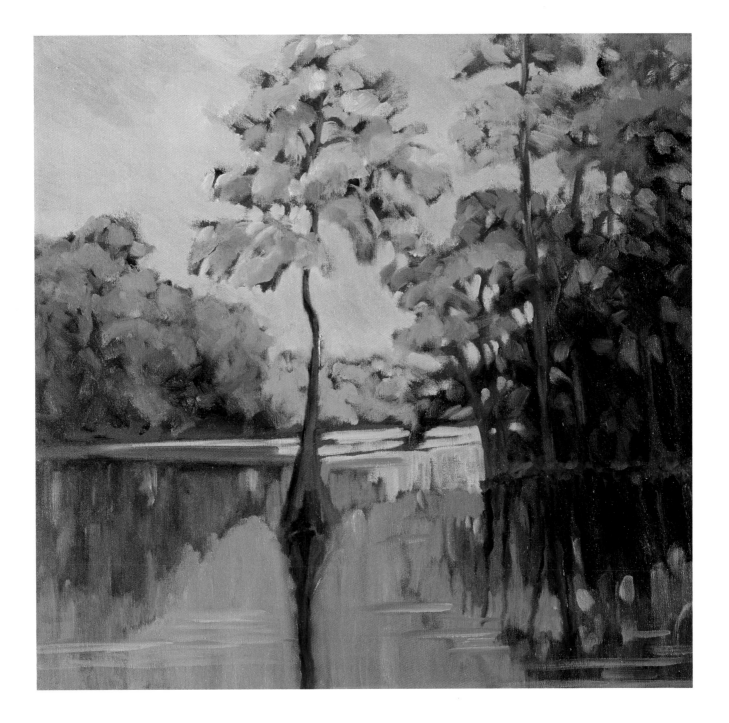

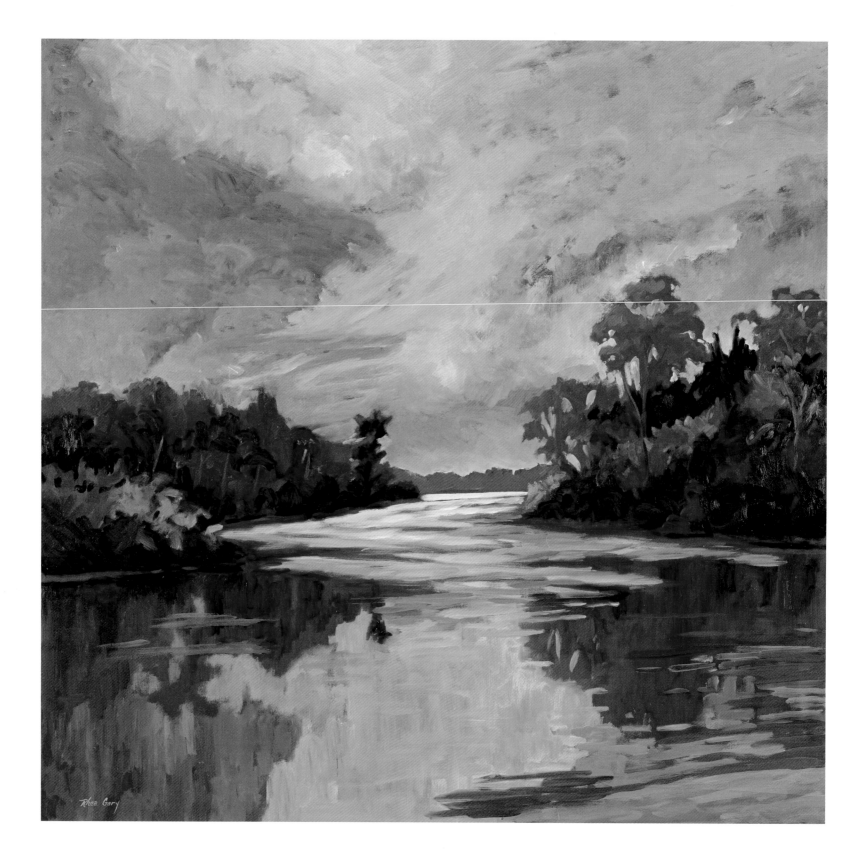

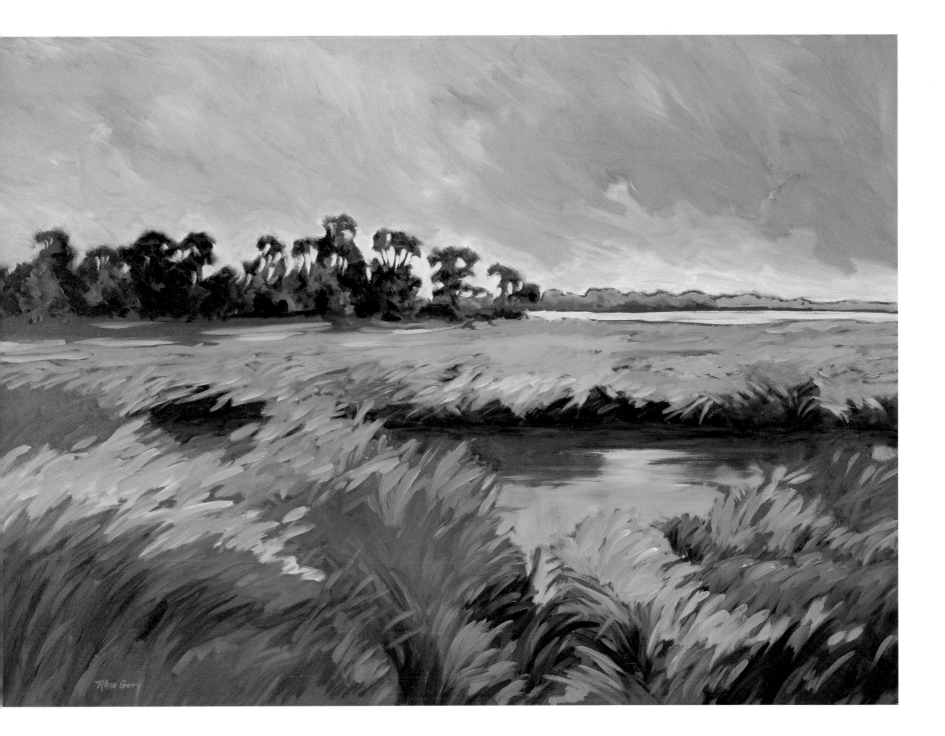

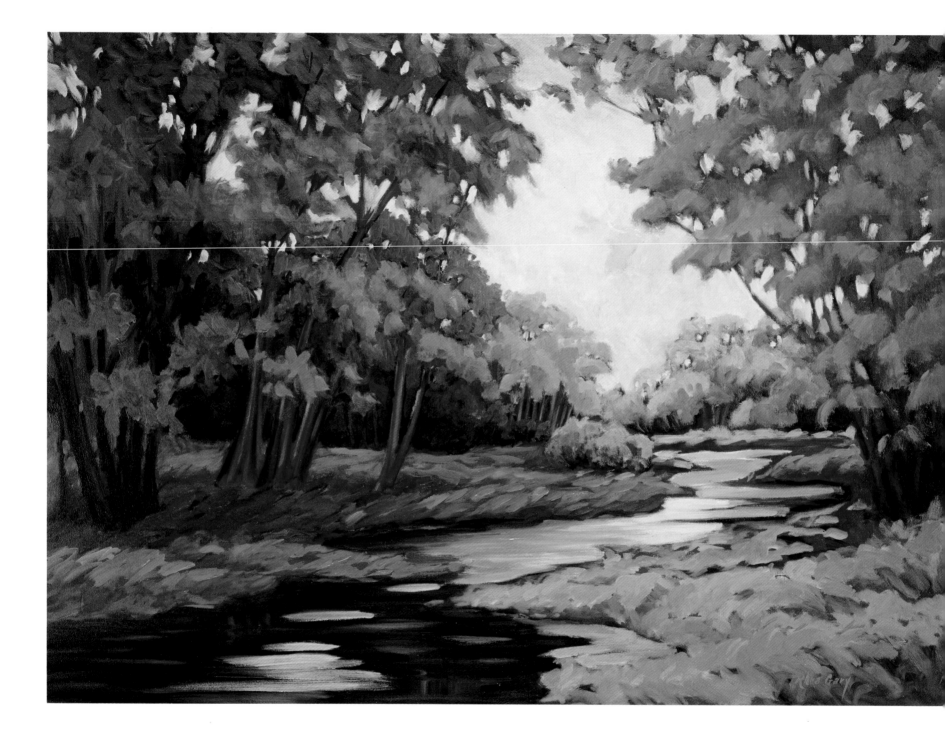

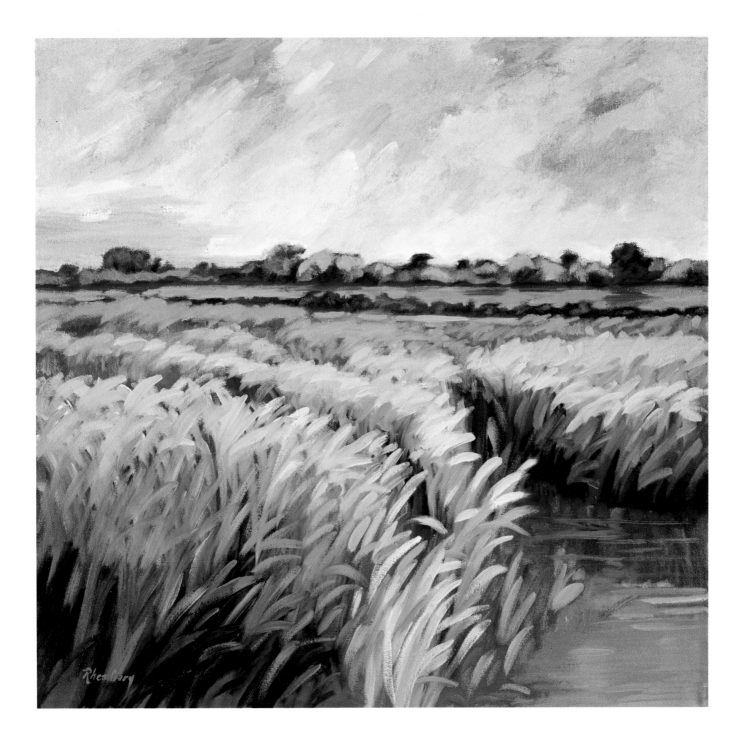

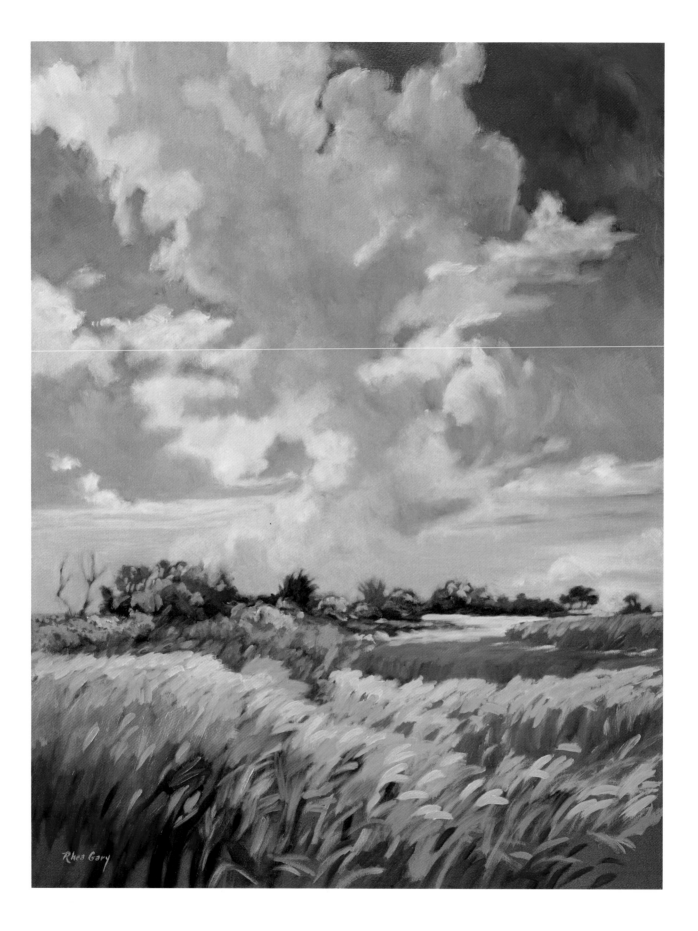

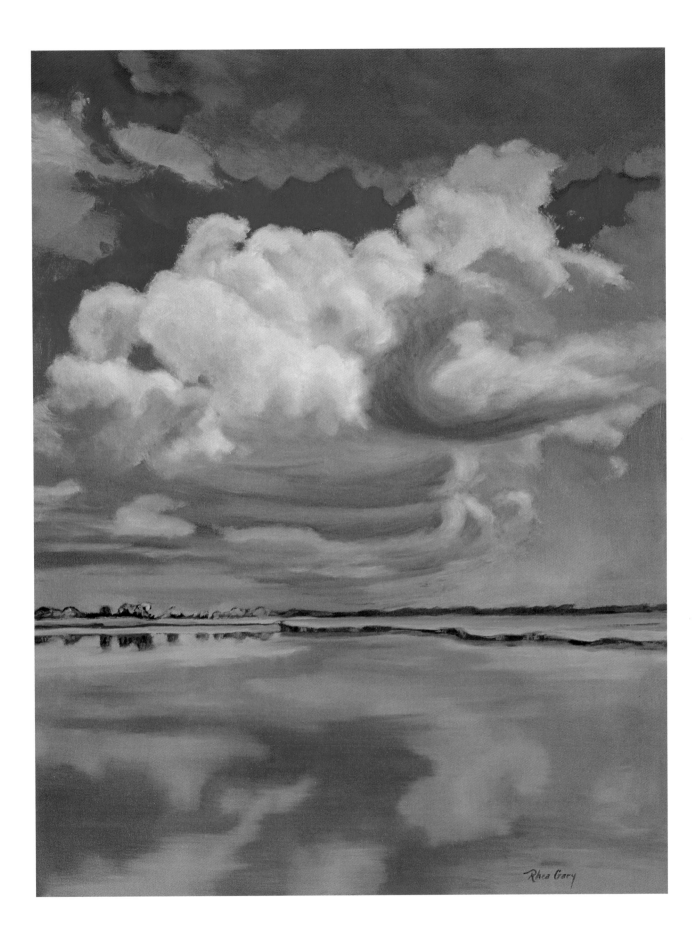

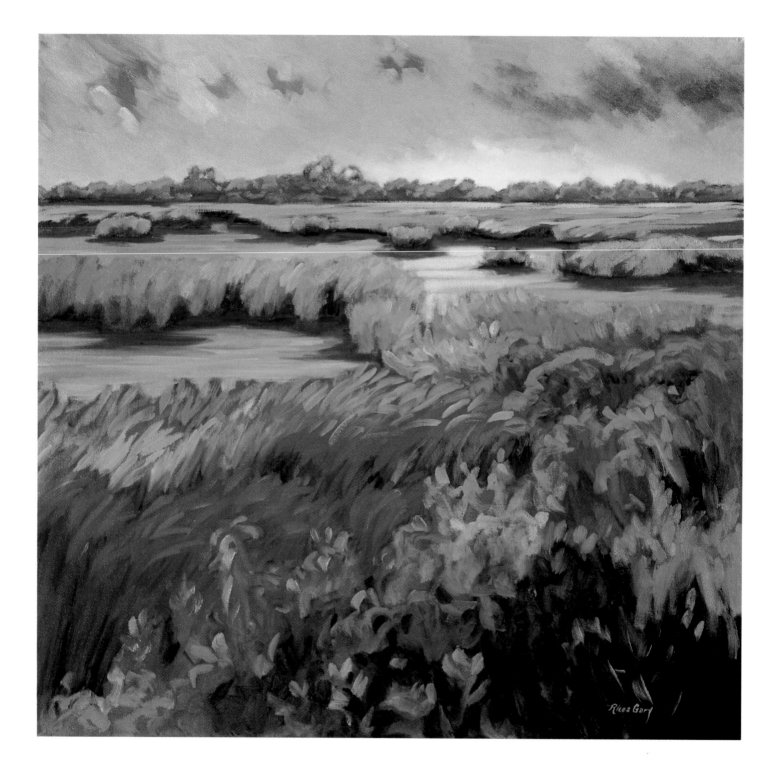

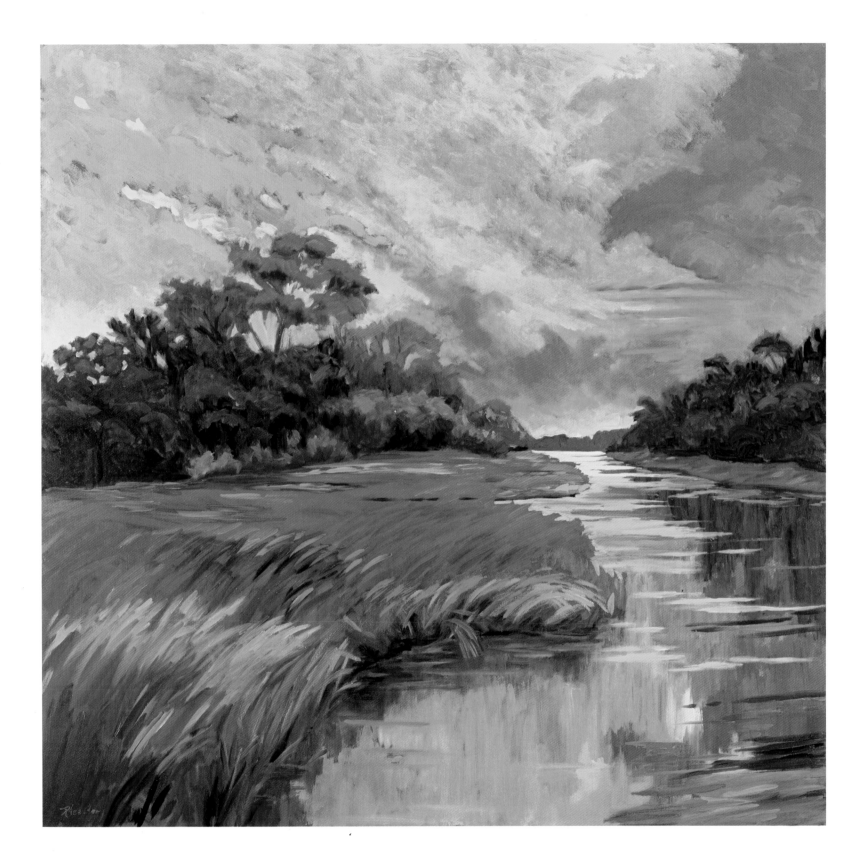

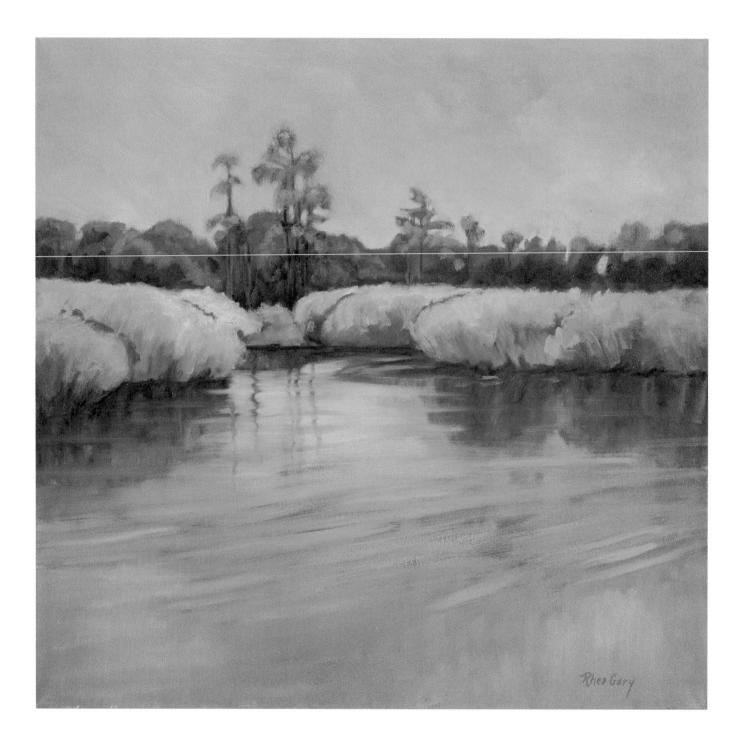

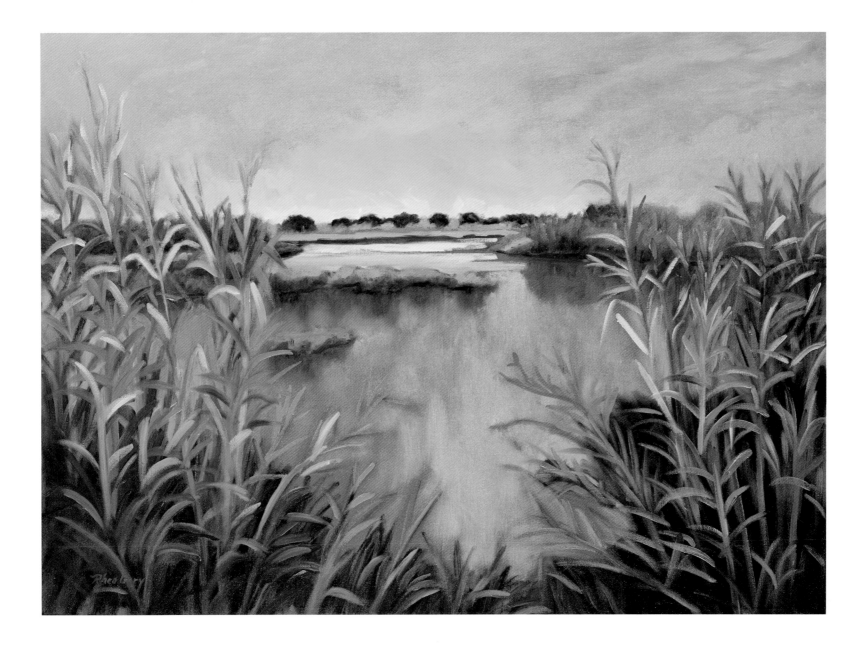

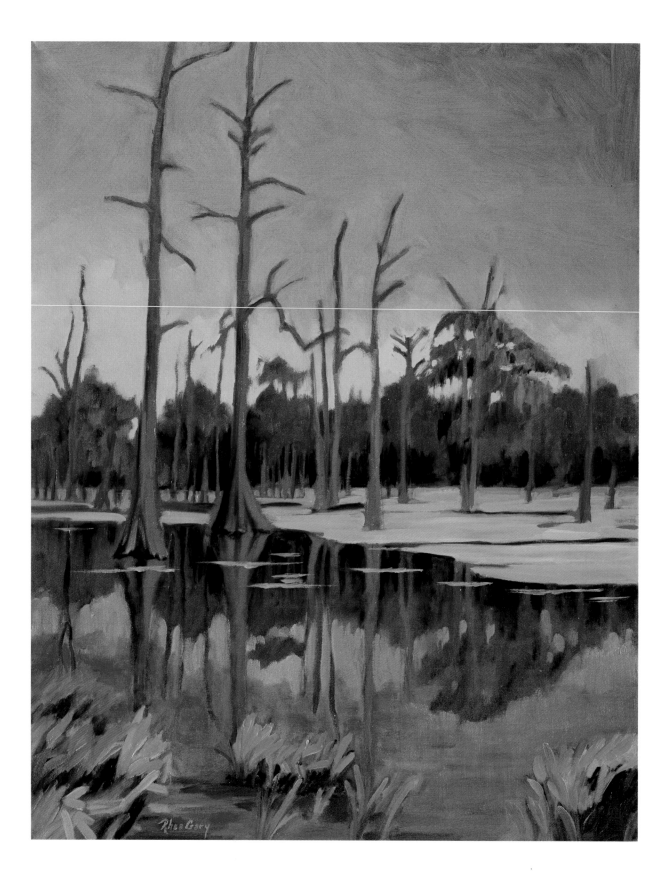

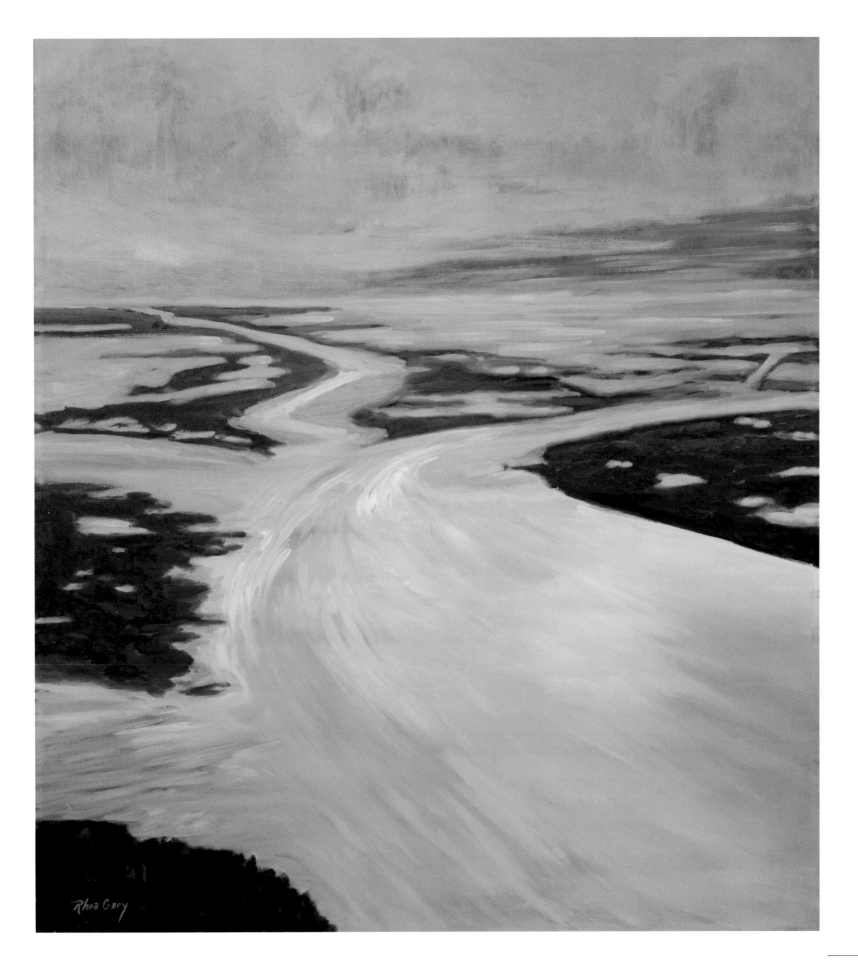

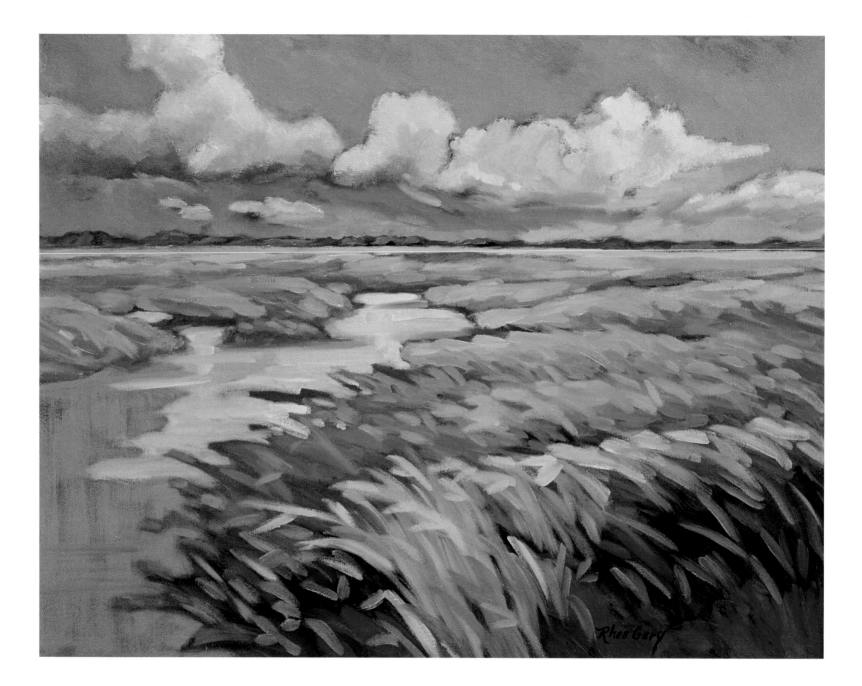

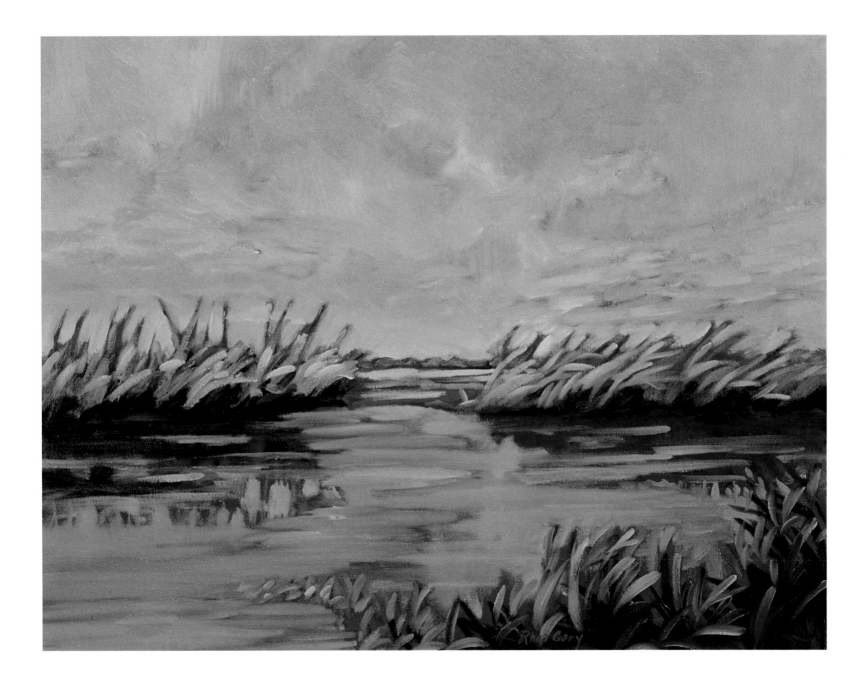

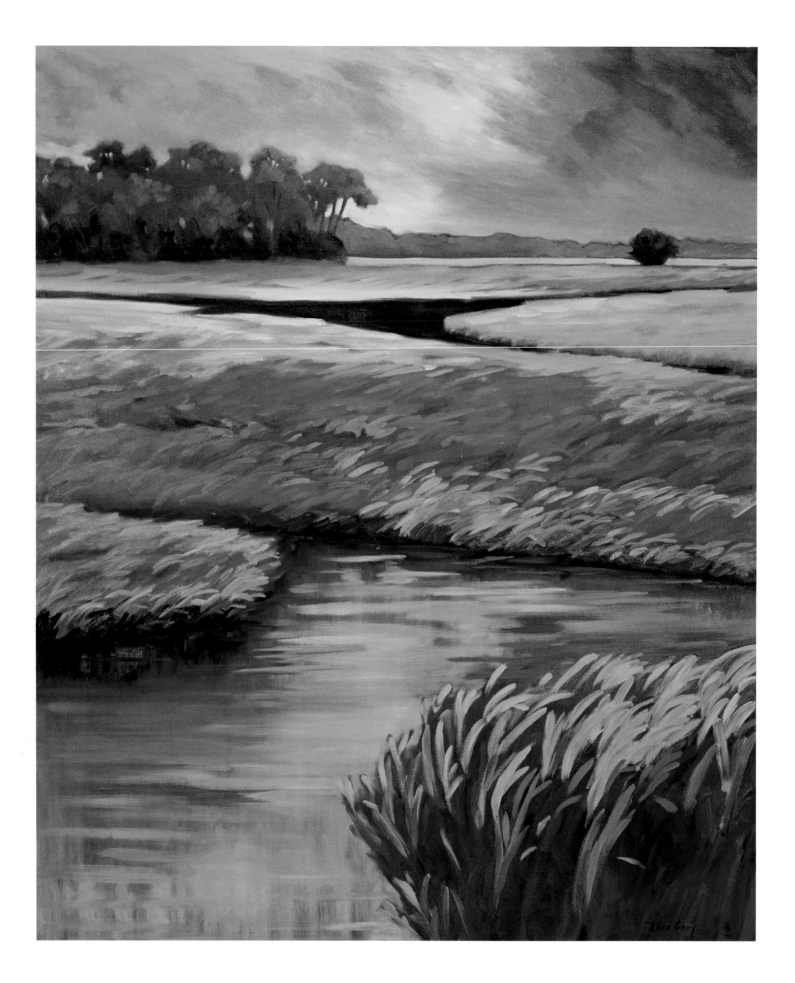

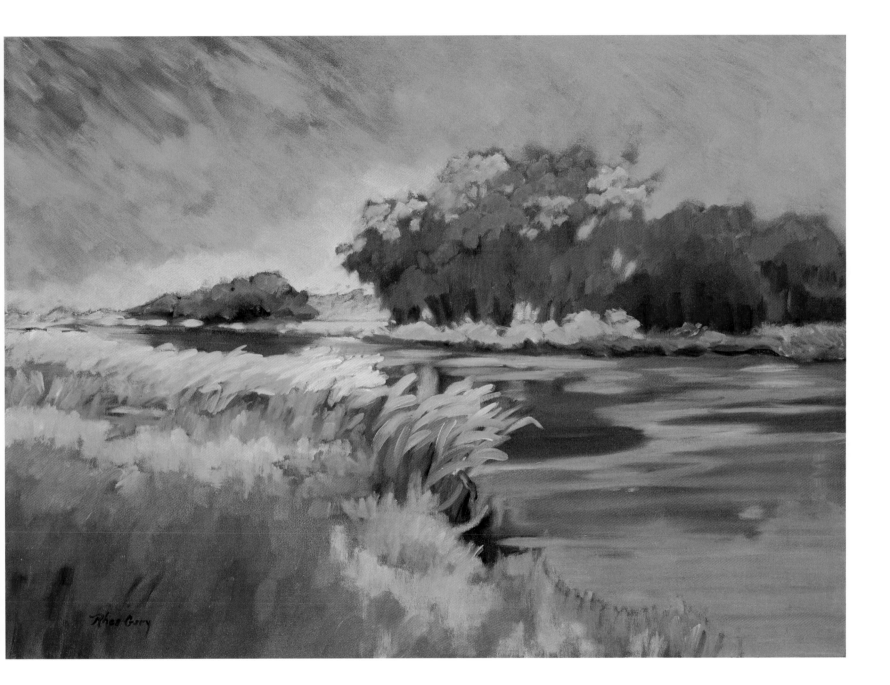

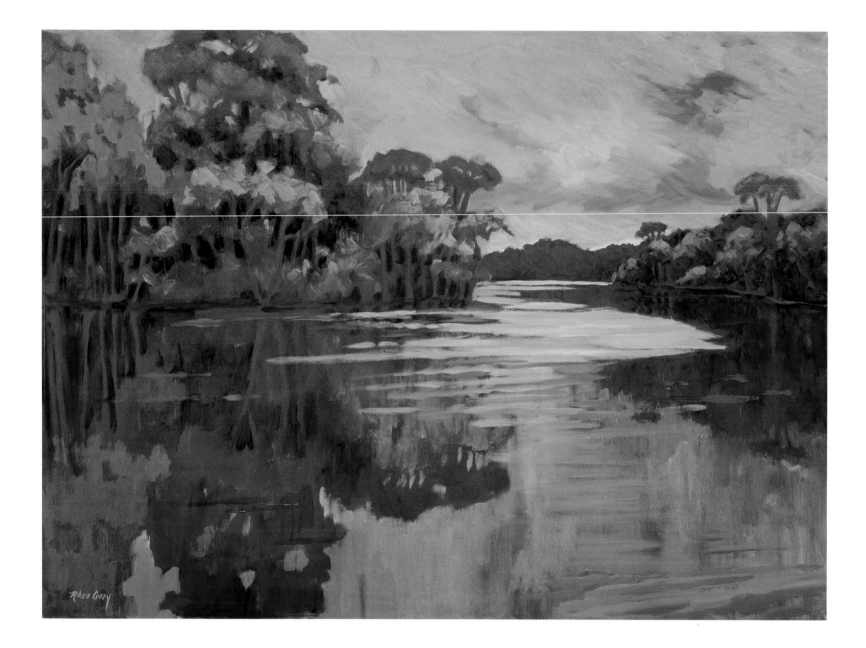

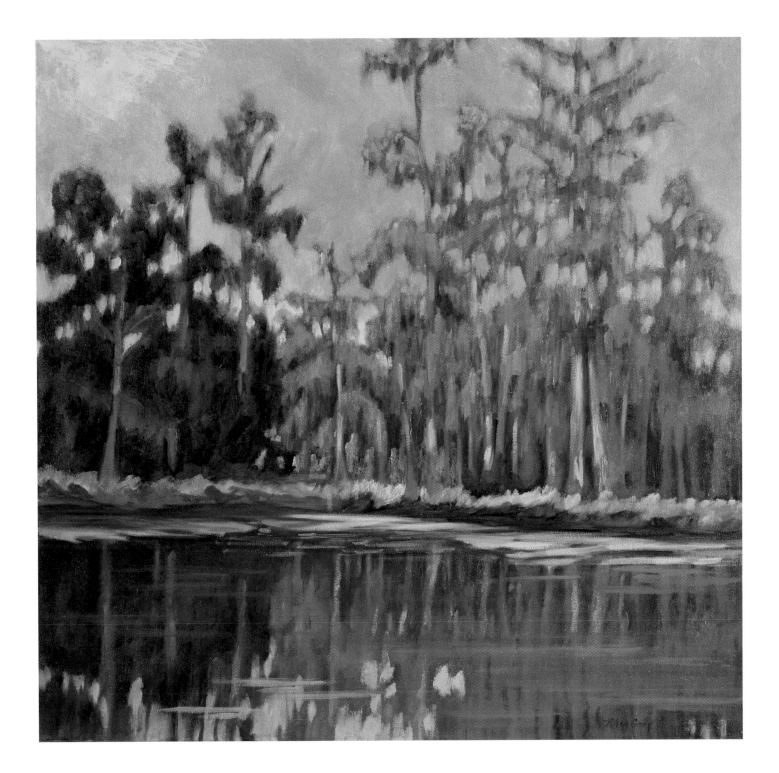

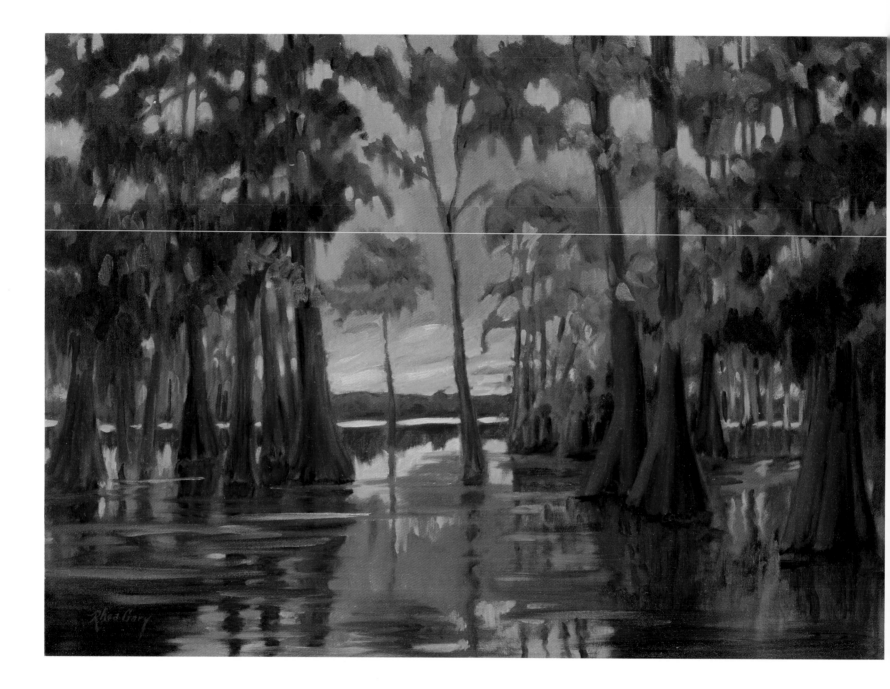

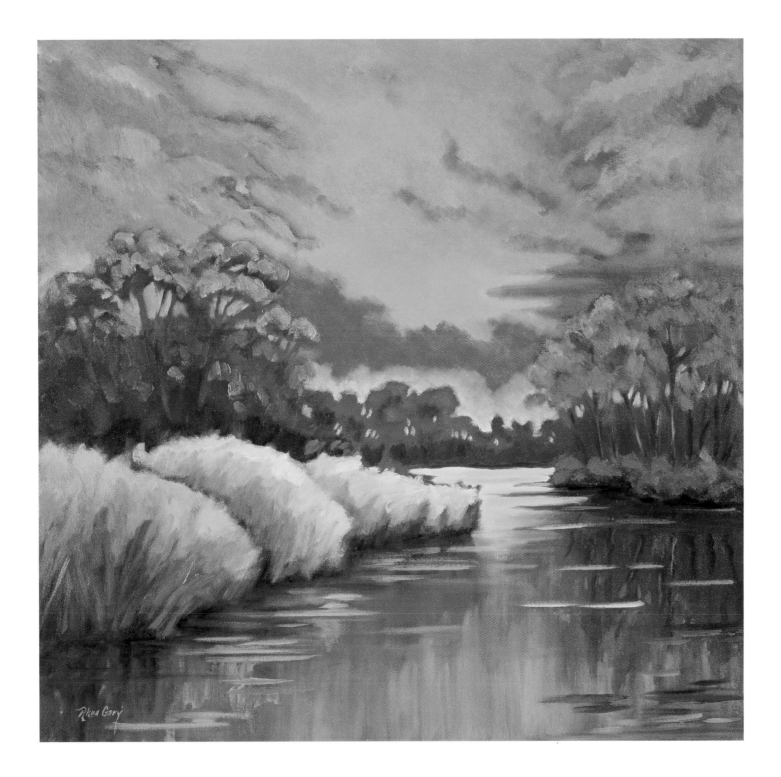

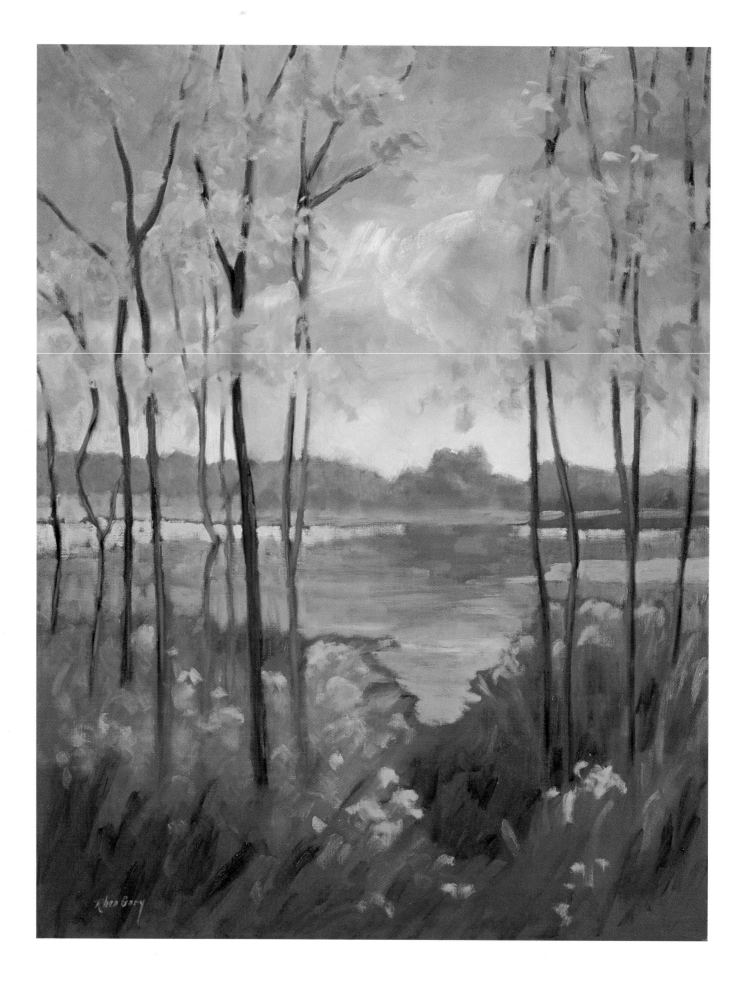

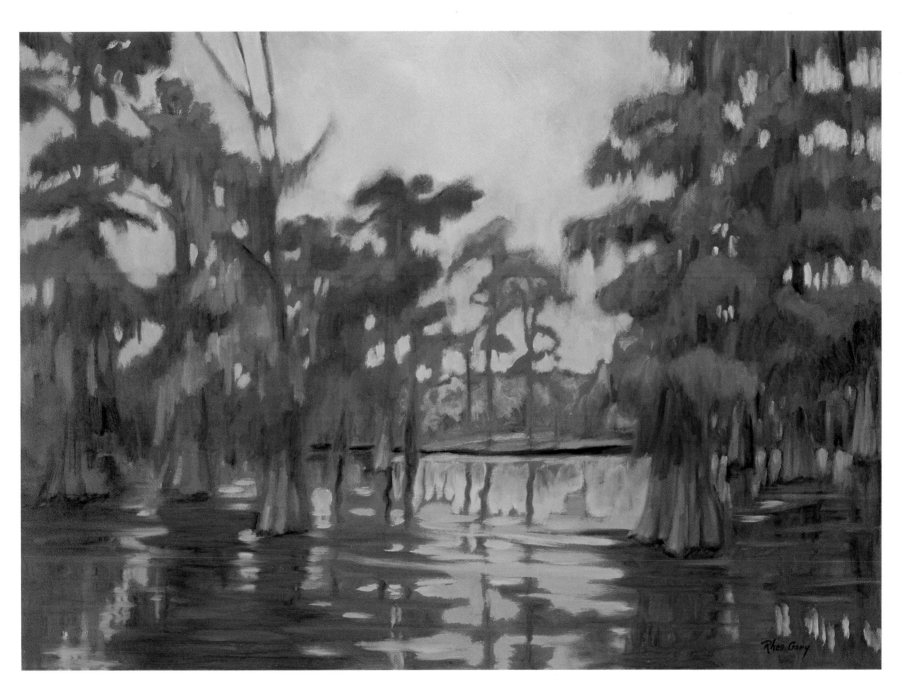

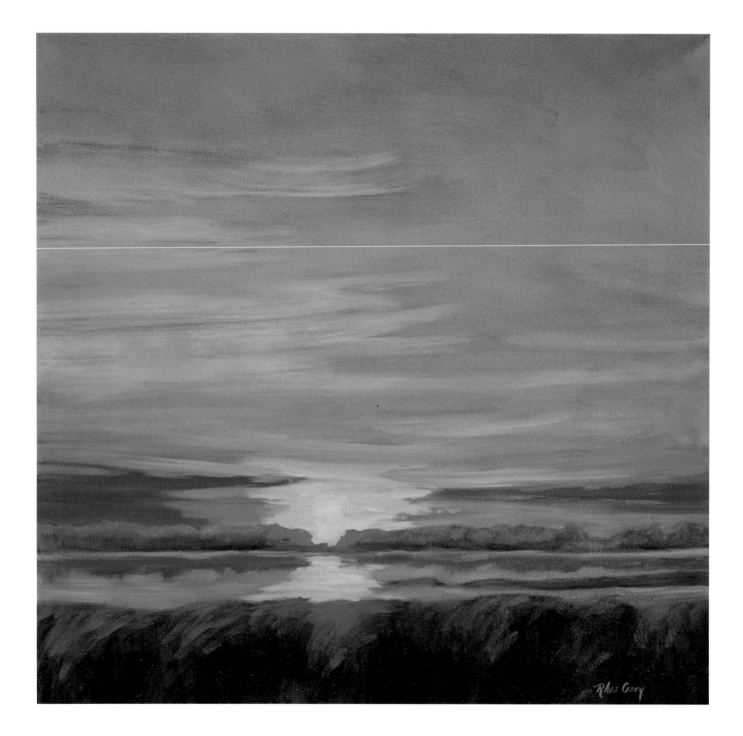

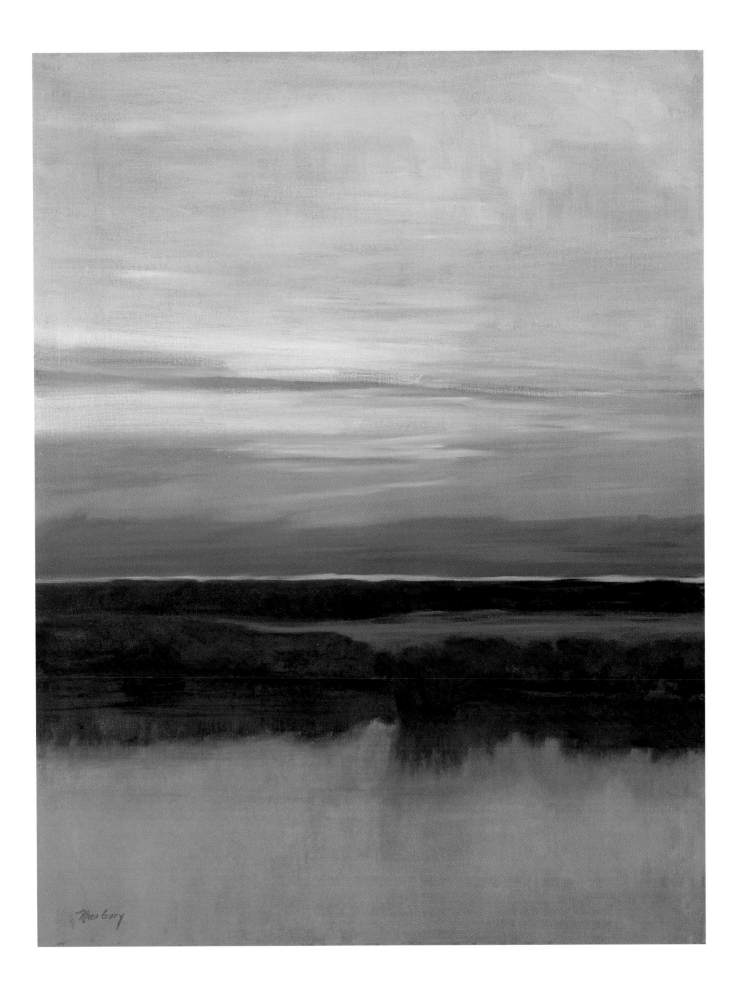

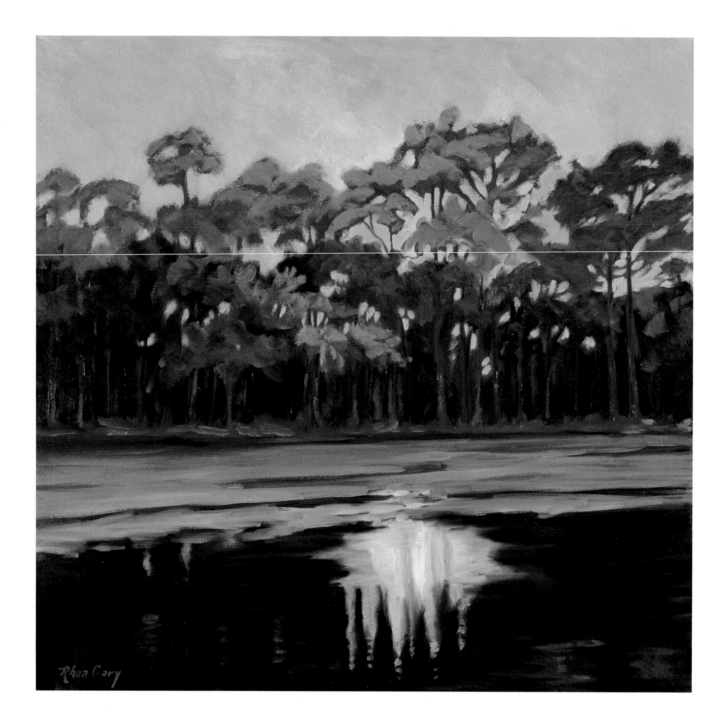

Epilogue

C. C. LOCKWOOD

For thousands of years the mighty Mississippi River has spewed its cargo of sediment into the shallow waters of coastal Louisiana. Like a garden hose on the loose, the river has slithered back and forth building eight thousand square miles of wetlands with its silt-laden waters. This newly accreted marshy soil has continuously subsided but was regularly replenished until we altered the Mississippi River by lining it with levees. In the short time of about 150 years we have lost 1,900 square miles, about 25 percent of the wetlands the mighty river has contributed to Louisiana's coast. Louisiana's wetlands continue to erode at a rate of twenty-four square miles per year, or a football field every thirty-eight minutes.

With over a billion pounds landed in 2002, Louisiana's fisheries are second only to Alaska's in the nation. The coastal wetlands provide valuable fur and alligator harvests along with ecotourism and recreational opportunities for hunting, fishing, bird-watching, photography, and boating. They are home to abundant and diverse wildlife populations, including over 5 million wintering waterfowl. Four of our nation's ten busiest ports are in Louisiana. Oil and gas production and distribution facilities in the state, both onshore and offshore, feed the heaters and automobiles of all Americans. South Louisiana is home to 2 million spicy, fun-loving people who have brought to the world a culture rich with good food, lively music, and friendly lifestyle. Perhaps the most important function of our vanishing coastline is the protection it gives this rich culture and bountiful land against hurricane tidal surge.

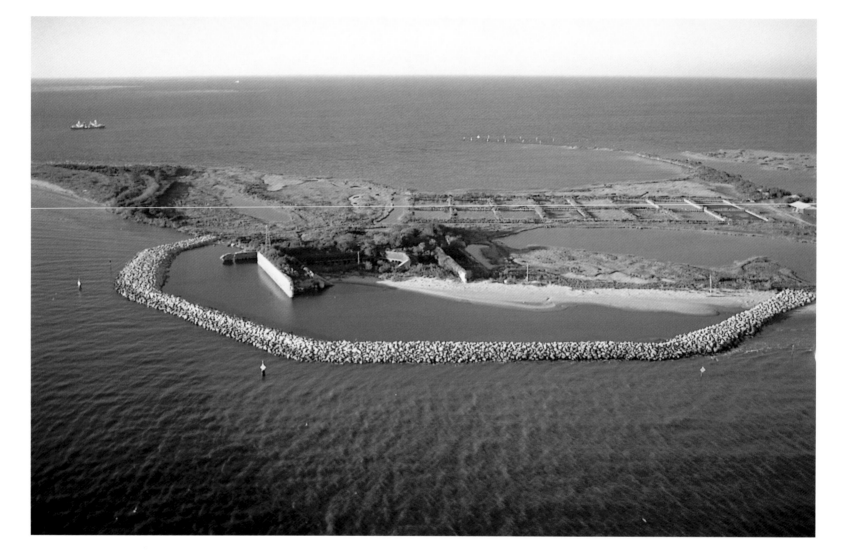

More than 35,000 tons of granite boulders protect the crumbling walls of Fort Livingston on the southwestern edge of Grand Terre. A Louisiana Department of Natural Resources / National Oceanic and Atmospheric Administration project placed these rocks here at a cost of $1.7 million to prevent the shoreline of this barrier island from retreating further and to keep the fragile walls of this historic fort from falling into the Gulf of Mexico. Is this the way to save our vanishing marsh and coastline? It's a partial solution, but to stem the tide of this devastating environmental problem, the clays, silts, and sands of the Mississippi River need to flow again into the marsh.

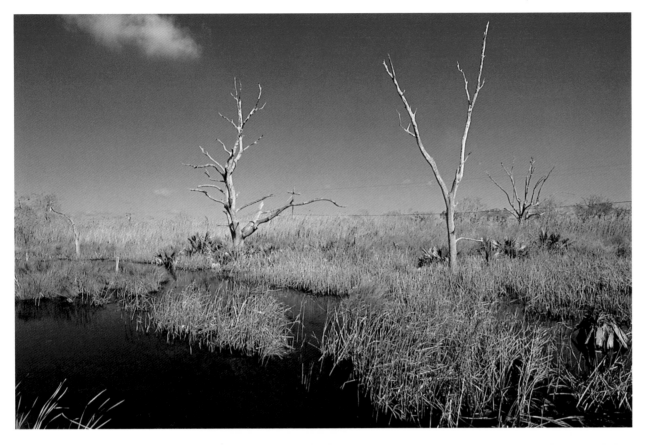

Subsidence (the gradual sinking of the land) and saltwater intrusion killed these oak trees in the marsh north of Cocodrie.

The skeleton of a dead live oak stands on the edge of an eroding beach on Cheniere au Tigre. The camp in the distance once had a road and forty feet of beach in front of it.

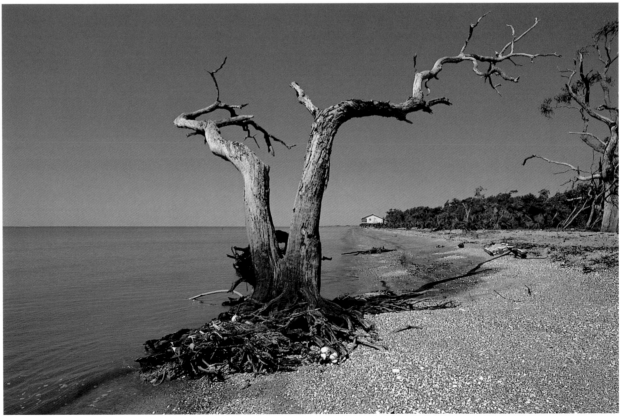

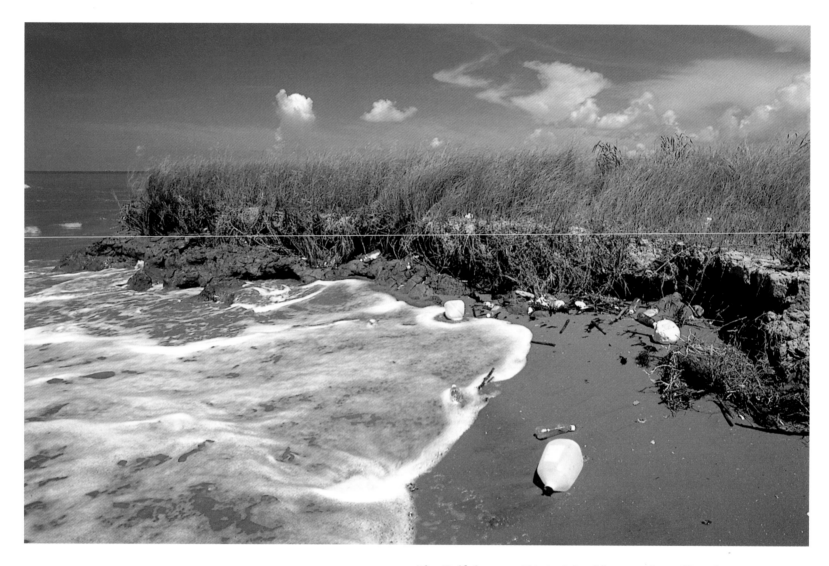

The Gulf shore on Trinity Island lost 293 feet of beach in 2002 because of Hurricanes Isadore and Lili. During a normal year the barrier islands of Louisiana lose thirty to forty feet per year.

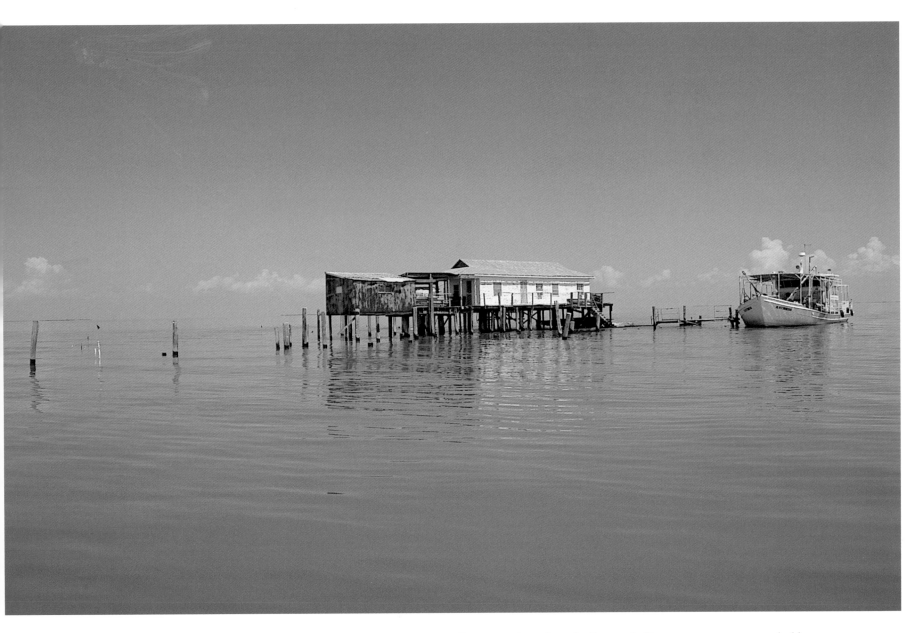

Camps such as these in Barataria Bay once were surrounded by marsh islands now lost to subsidence.

Waves in East Cote Blanche Bay will soon destroy this strip of marsh grass dividing the bay from a bayou, which will in turn lead to the rapid loss of another sixty feet of wetlands.

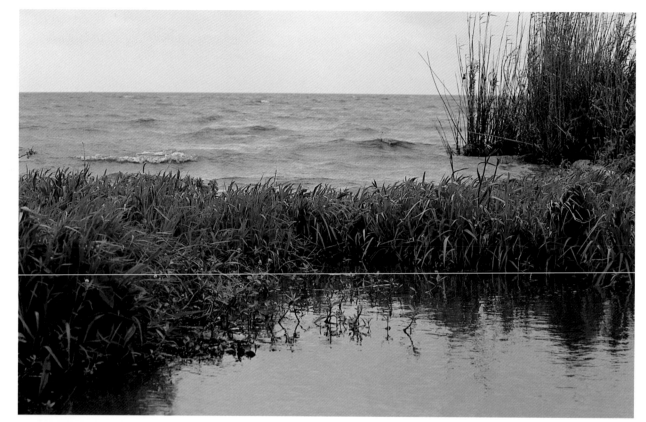

Many minor problems such as boat wakes erode the banks and widen the canals constructed for navigation and oil field access. There are eight thousand miles of canals in coastal Louisiana.

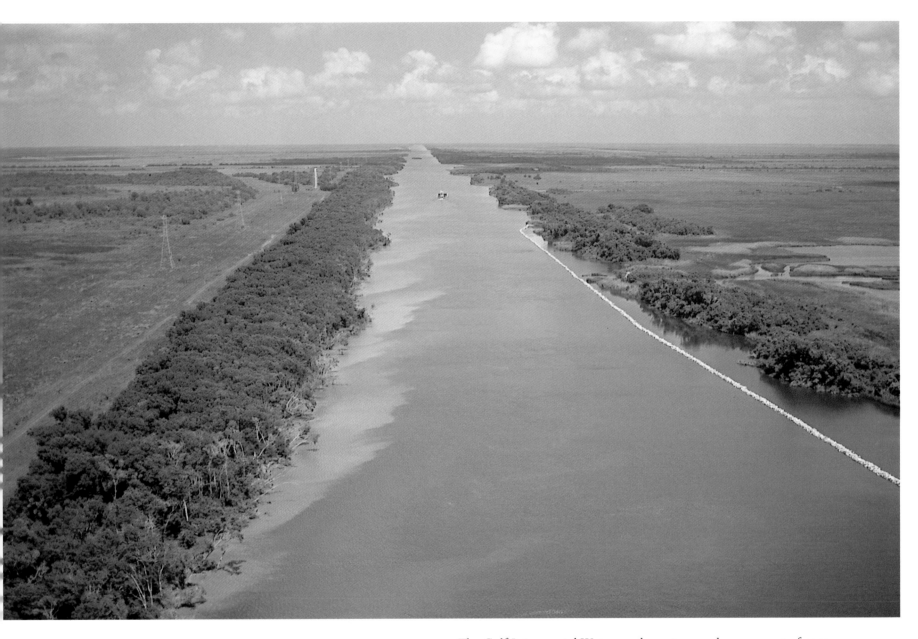

The Gulf Intracoastal Waterway has a tremendous amount of commercial traffic and has been widening for years. Note the silty water on the south side here caused by boat wakes compared with the clear water on the north side, which is protected by rocks installed by a CWPPRA project. Grass planted by the project is helping the marsh grow back toward the rocks.

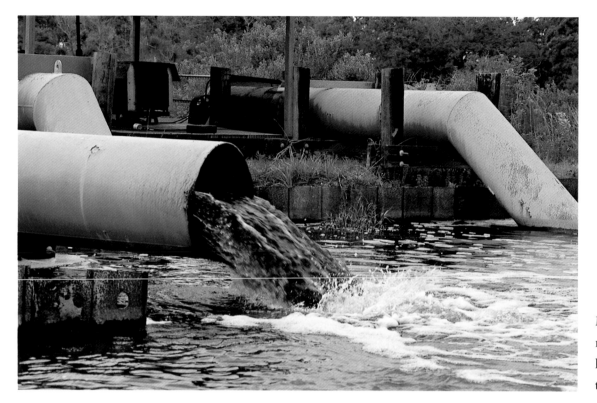

Many landowners protect their marshes with pumps or bank stabilization using everything from old tires to discarded Christmas trees.

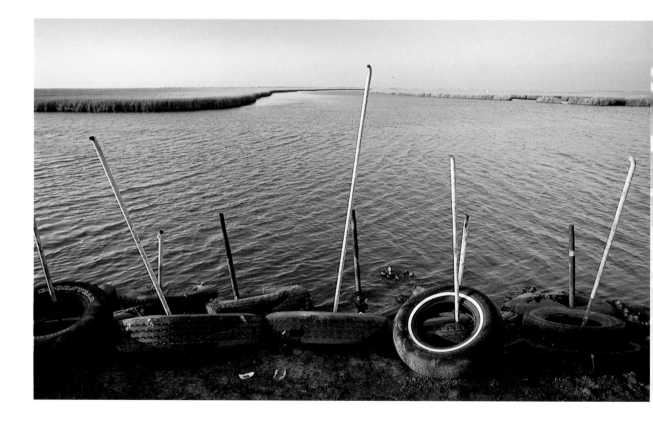

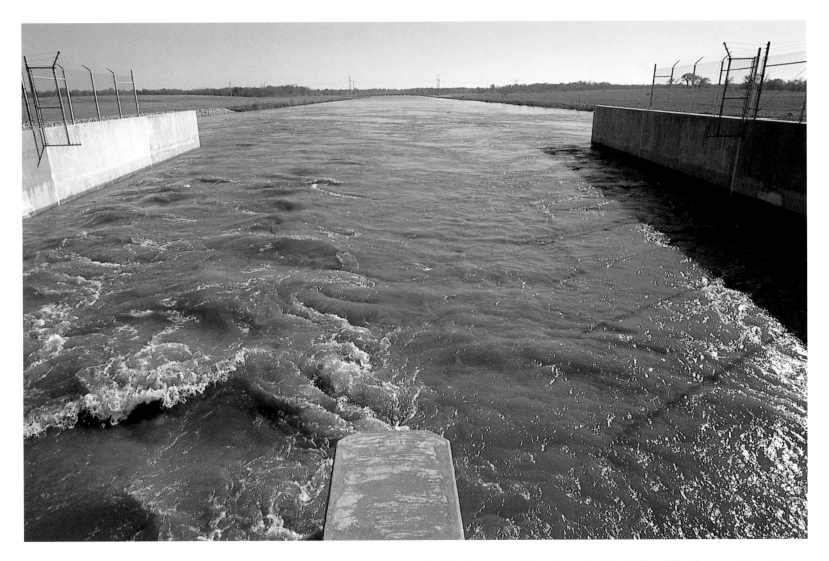

The freshwater outflow from the Davis Pond Freshwater Diversion Structure will reduce the salinity in Lake Salvador and the marshes to the south and also add a small amount of sediment. The structure diverts fresh water from the Mississippi River under the levee and into the pond.

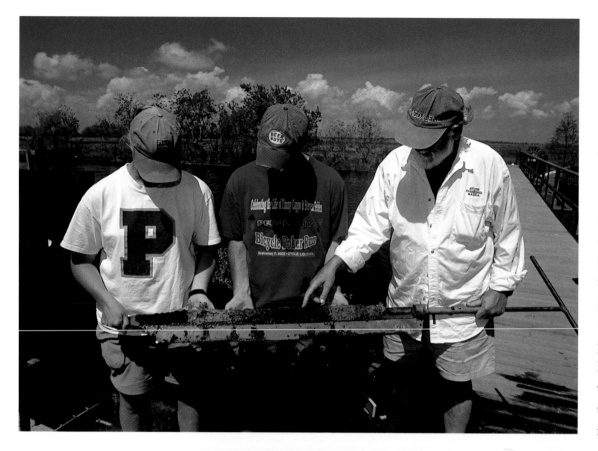

A soil core sample taken from the marsh behind the Caernarvon Freshwater Diversion Project shows in telling detail the difference between natural soil accretions and those resulting from human intervention. From left to right are pre-1927 black peat, gray clay form the flood of 1927, roots and decayed marsh grass accreted between 1927 and 1992 when the Caernarvon project began operation, and then the gray clay of sediment added from the project's initiation to 2004. Comparison of the 1927 and post-1992 strata vividly illustrates how in six months natural floodwaters added as much sediment as twelve years of flow from this man-made structure.

Shrimping in Barataria Pass, one of the many forms of seafood harvest from the wetland ecosystem of the Louisiana coast.

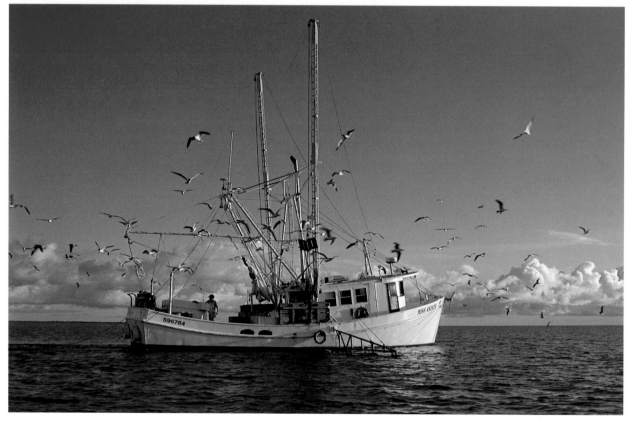

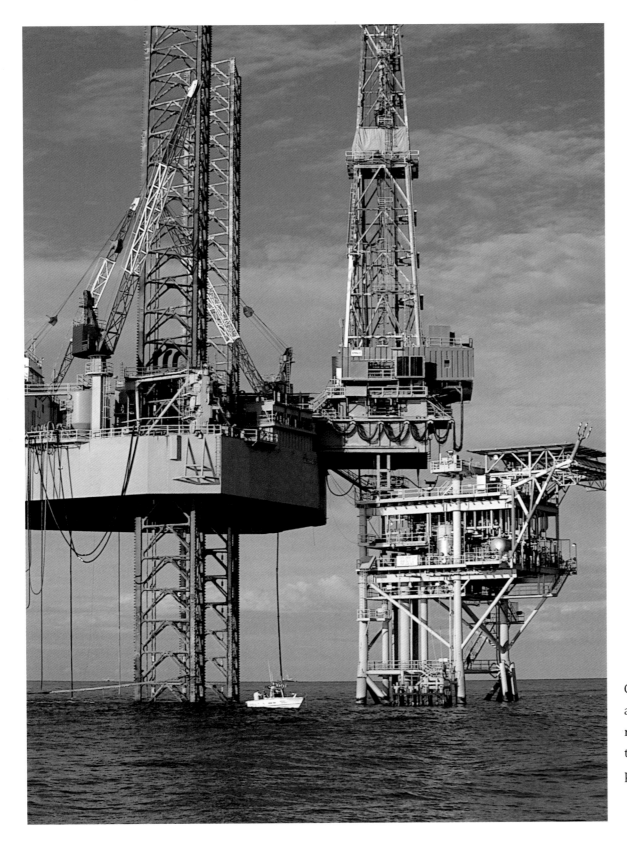

Offshore oil and gas wells
and the pipelines heading west,
north, and east produce and
transfer 30 percent of America's
petroleum products.

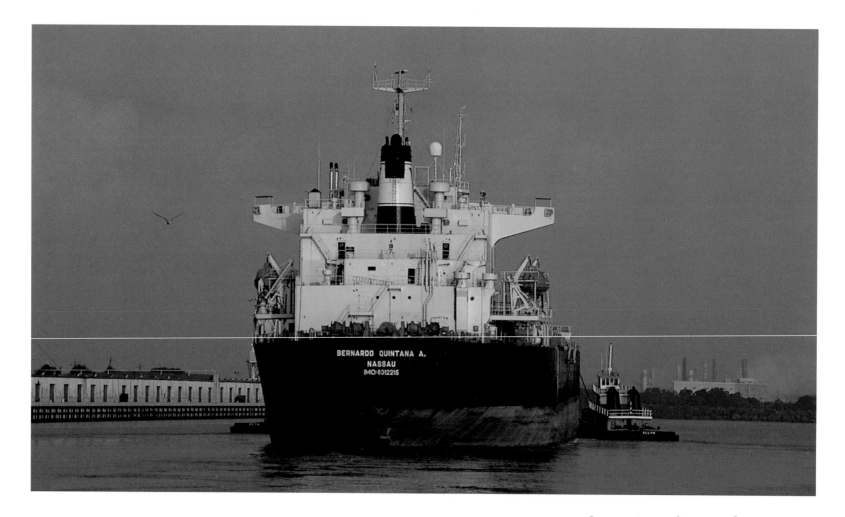

Oceangoing tankers visit five major ports in Louisiana; these along with the Gulf Intracoastal Waterway provide valuable commerce to all Americans.

Edges of marsh grass and water make the habitat that produce the shrimp, crab, oysters, and fish that in turn feed other wildlife and man alike. This is a lovely wetland, subtle in places and wild in others. Today for better or worse it is tied to our people, recreation, industry, and commerce.

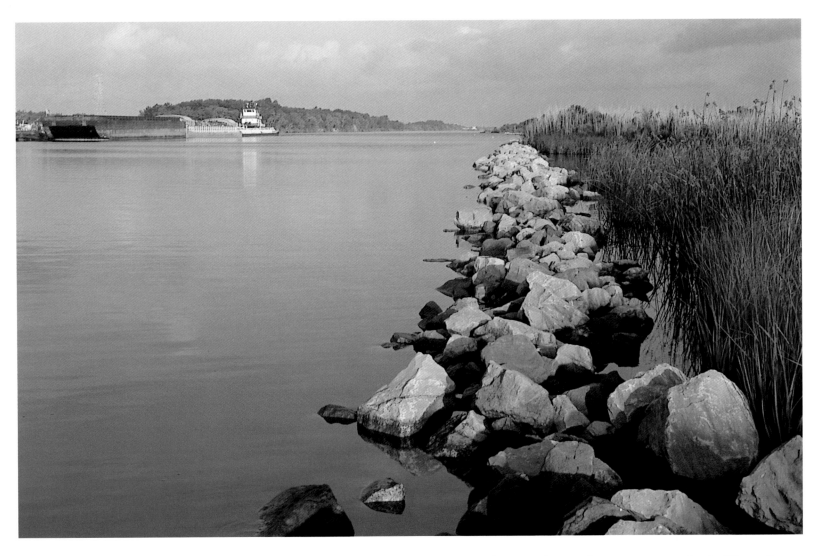

It's going to take more than rocks to save our wetlands. We need these barriers, along with dune restoration, marsh grass plantings, canal backfilling, and pollution clean up, but most of all we need more structures like those pictured on pages 95 and 96 to help build up sediment to counteract the persistent subsidence along the coast.

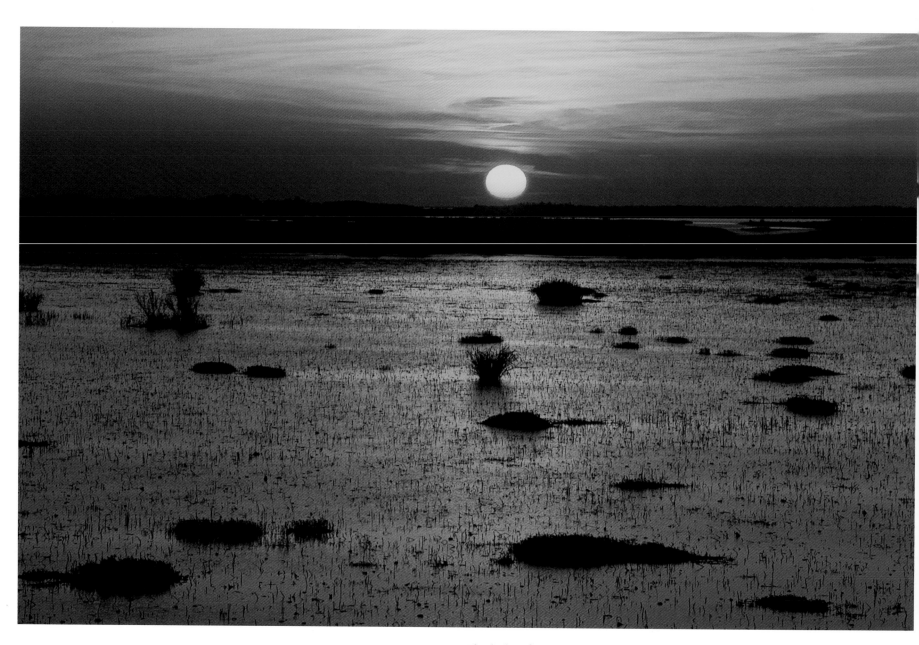

The light of a golden sunset over the newly accreted marsh at Wax Lake Outlet gives us hope that we can restore Louisiana's vanishing wetlands if we can get new sediment into the critical areas.

For more information, visit the Marsh Mission Web site, www.marshmission.com.

List of Plates

Winter Marsh
Jefferson Parish

Spoonbills Return
Cameron Parish

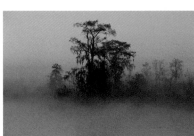

Bald Cypress Hope
Terrebonne Parish

Marsh Flight
Terrebonne Parish

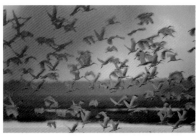

Spring Is Here
Terrebonne Parish

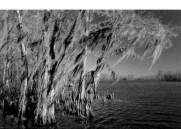

Sunk in Twenty Years
Lafourche Parish

Rustic Rainbow
Lafourche Parish

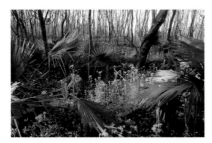

Winter Wildflowers
Terrebonne Parish

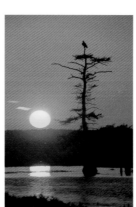

America's Wetland
Terrebonne Parish

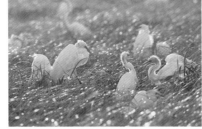

Radiant Rookery
Cameron Parish

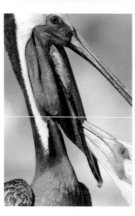

Bonding
Jefferson Parish

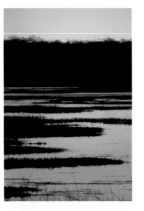

Golden Glow
Terrebonne Parish

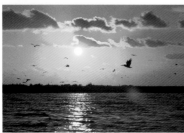

Pelican Sunset
Jefferson Parish

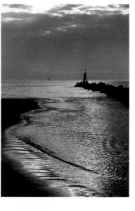

Paper-Scissors-Rocks
Jefferson Parish

Purple Paradise
St. Mary's Parish

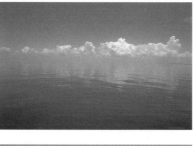

Marsh Gone
Plaquemines Parish

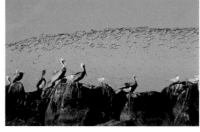

Abundant Avians
Jefferson Parish

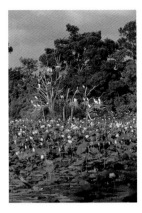

Rookery in Lotus
Vermilion Parish

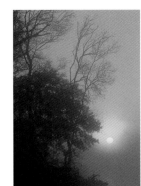

Wetland's Edge
Terrebonne Parish

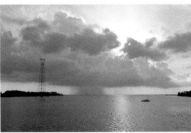

Dangerous Afternoon
Lafourche Parish

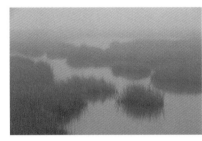

Lost Marsh
Lafourche Parish

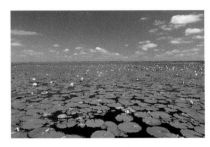

Monet's Marsh
Cameron Parish

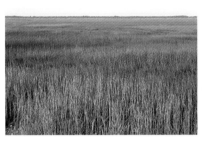

Wild Wetlands
Vermilion Parish

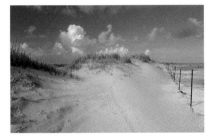

Doubtful Dune
Terrebonne Parish

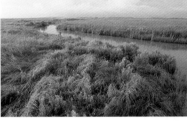

Luxuriant Wetlands
Iberia Parish

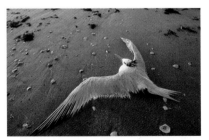

Embrace the Last Beach
Terrebonne Parish

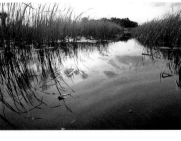

Trenasse
Calcasieu Parish

Last Sunset
Lafourche Parish

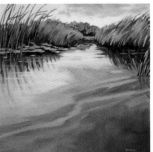

Calcasieu Marsh
36" x 36"

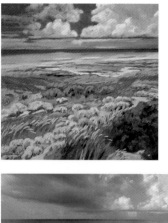

All That Remains

40" x 40"

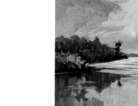

Hold Back the Storm

Terrebonne Parish

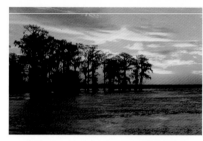

Atchafalaya Sunrise

St. Martin Parish

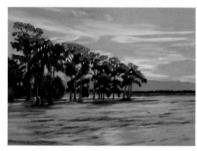

Sunset—Flat Lake

30" x 40"

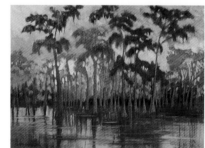

Tchefuncte Awakening

36" x 48"

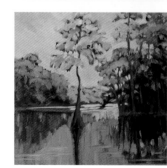

Set Apart

20" x 20"

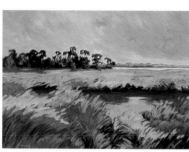

Sensuous Summer

48" x 48"

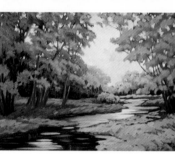

Marsh Memory

36" x 48"

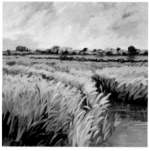

*Meandering through
Henderson Swamp*

36" x 48"

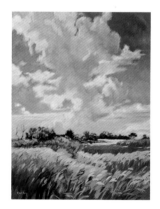

Late Fall Marsh

36" x 36"

Cloud Cover

48" x 36"

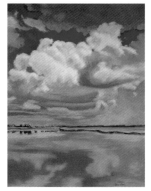

Spring—Rockefeller Wildlife Refuge

48" x 36"

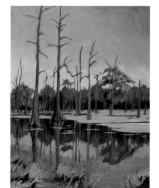

Silent Pickets

40" x 30"

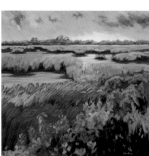

Morning Marsh

40" x 40"

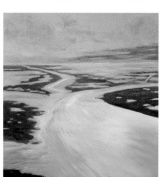

Head of Passes

60" x 48"

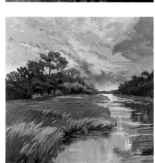

Bayou Reflections

48" x 48"

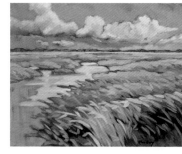

Wind Whisper

24" x 30"

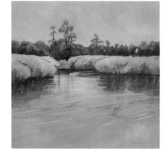

Early Fall Mandalay

36" x 36"

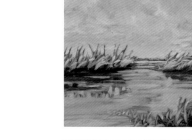

Going, Going, Gone

24" x 30"

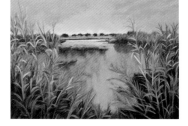

Sunrise—Rockefeller Wildlife Rufuge

30" x 40"

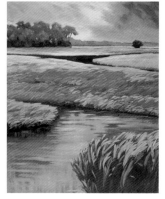

Marsh Enchantment

60" x 48"

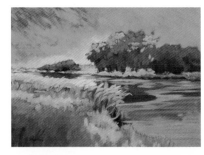

Pointe aux Chenes
30" x 40"

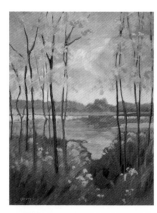

Marsh Enchantment
48" x 36"

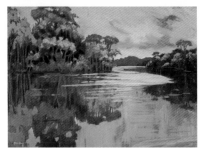

Southern Exposure
30" x 40"

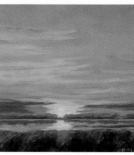

Dressed for Fall
36" x 48"

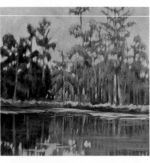

Winter Cypress on Hanson Canal
40" x 40"

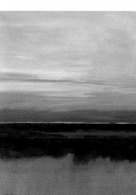

Fire Light
36" x 36"

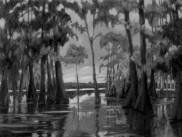

Lake Sunset
30" x 40"

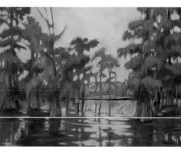

Transition
48" x 36"

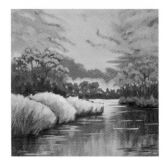

Sunset Mandalay
40" x 40"

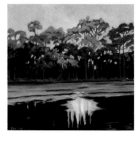

Sunset Bayou Corne
30" x 30"

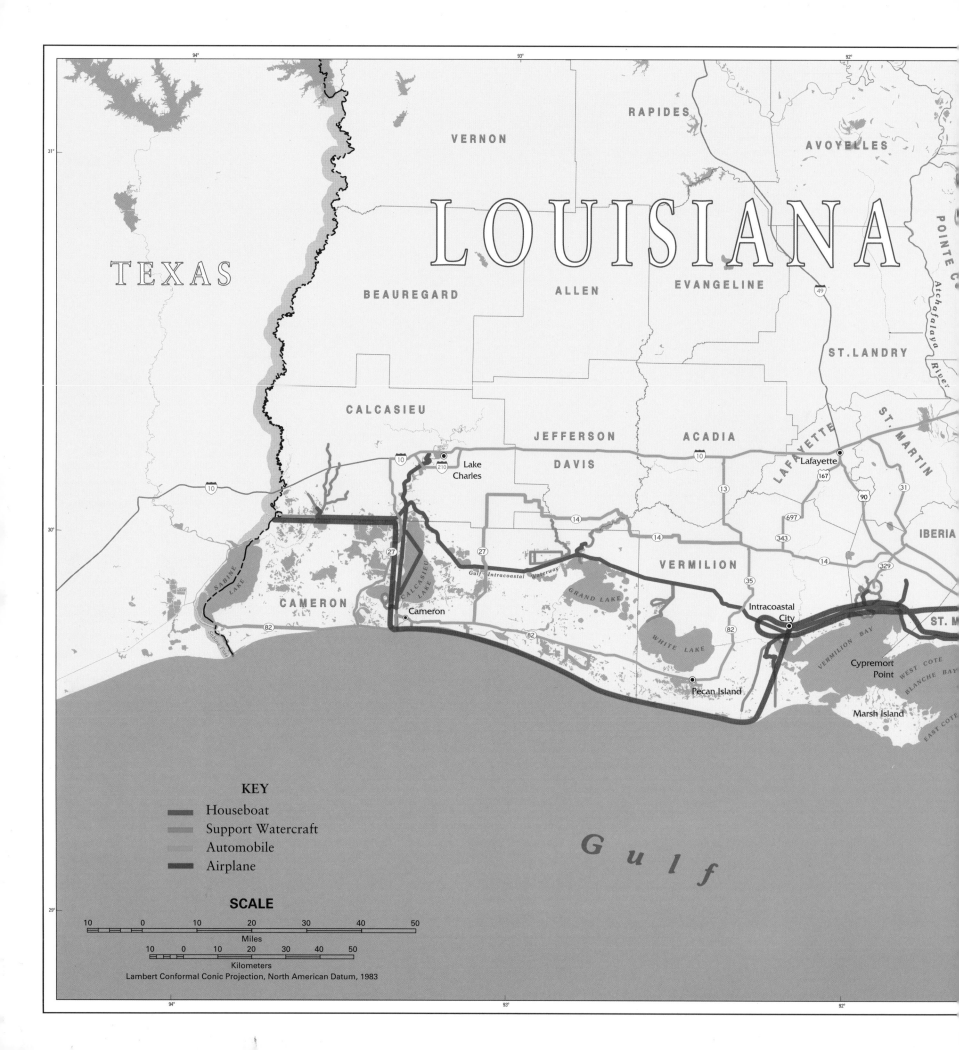

LOUISIANA

TEXAS

VERNON

RAPIDES

AVOYELLES

BEAUREGARD ALLEN EVANGELINE

ST. LANDRY

CALCASIEU

JEFFERSON ACADIA

DAVIS

Lake
Charles

Lafayette

VERMILION

SABINE LAKE

CAMERON

CALCASIEU LAKE

Gulf Intracoastal Waterway

GRAND LAKE

Intracoastal
City

ST. M

Cameron

WHITE LAKE

VERMILION BAY

Cypremort
Point

WEST COTE

BLANCHE BAY

IBERIA

Sabine Pass

Pecan Island

Marsh Island

EAST COTE

KEY

━━━ Houseboat
━━━ Support Watercraft
━━━ Automobile
━━━ Airplane

Gulf

SCALE

10 0 10 20 30 40 50
Miles

10 0 10 20 30 40 50
Kilometers

Lambert Conformal Conic Projection, North American Datum, 1983